Watercolour Animals for the Absolute Beginner

This book is dedicated to my
nephews and nieces,
Oliver, Georgina,
Bradley and Violet.

Watercolour Animals for the
Absolute Beginner

MATTHEW PALMER

Search Press

First published in 2024

Search Press Limited, Wellwood, North Farm Road,
Tunbridge Wells, Kent TN2 3DR

Text copyright © Matthew Palmer, 2024

Photographs by Mark Davison at Search Press Studios

Photographs and design copyright © Search Press Ltd 2024

ISBN: 978-1-80092-050-7
ebook ISBN: 978-1-80093-043-8
SAA Edition ISBN: 978-1-80092-298-3

Suppliers
If you have difficulty in obtaining any of the materials and
equipment mentioned in this book, then please visit the
Search Press website for details of suppliers:
www.searchpress.com

Extra copies of the outlins are available to download free
from the Bookmarked Hub. Search for this book by title or
ISBN: the files can be found under 'Book Extras'.
Membership of the Bookmarked online community is free:
www.bookmarkedhub.com

You are invited to visit the author's website at:
www.watercolour.tv

Publishers' note
All the step-by-step photographs in this book feature the
author, Matthew Palmer. No models have been used.

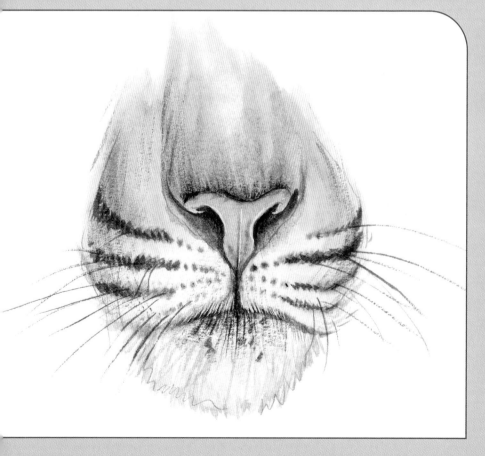

Acknowledgements

First of all a big thank you to all
my family for their continued help
and support in my art. A massive
thank you and lots of love to
my wife Sarah, and sons Jacob
and Theo. Their support and
love has gone a long way in the
creation of my books.

A big thank you to Jennie, whose
hard work is greatly appreciated,
and to all at the SAA for their
continued support. And finally, a
huge thank you to all at Search
Press, especially Carrie, Sam,
Caroline and Martin, and to
Juan for the design and Mark for
the photography.

Contents

Introduction 6

Materials 8

Colour 14

Sketching 22

Techniques 24

Elephant: Wet-into-wet 24
 Wet-into-dry 26
 Adding shadow 28
 Dry brush 34
 Lifting out 36
 Adding white paint 38
 Finishing touches 40
Tiger: Adding facial features 44

The projects 48

Penguins – step by step 50
Goldfinch – step by step 54
Dolphins – step by step 60
Parrot – step by step 68
Cheetah – step by step 82
Sea turtle – step by step 98
Panda – step by step 116
Polar bear – step by step 128
Giraffes – step by step 144

Index 160

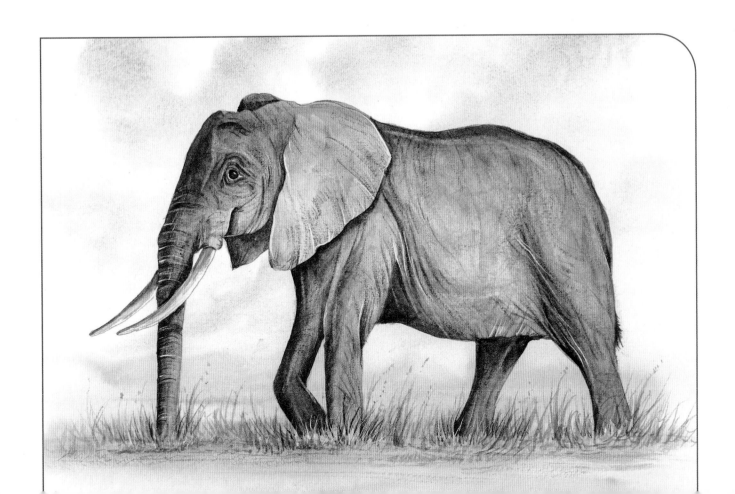

Introduction

I began painting at a very young age. Art was always a part of me and watercolour was the one medium that stood out from the crowd. I always had a natural flair for art – I could see shadows and angles in buildings, and the way light bounces off objects to create contrast. Over the years I developed my own art style and started teaching watercolours in the late 1990s. These classes soon grew very popular and led to workshop days, painting holidays and online virtual classes. My teaching career branched out to see me presenting **TV** shows, working on tuition **DVD**s and teaching thousands of students via online lessons on my video on-demand art website: www.watercolour.tv

One of the first subjects I ever painted was animals, and the pets in my childhood home were a great inspiration. So, painting cats and dogs was how it started for me, and I soon began painting wild animals, birds, safari animals and even insects.

Everything I know from my long history of painting animals in watercolour has been invested in this book – it literally showcases every technique I have learnt in this time period.

Using techniques like dry brush, lifting out to create stunning highlights, and building up strong shadows, is the secret to successful animal painting in watercolours.

This is a book of two halves. In the first section you will find all those essential techniques, tips and tricks needed to create your own animal watercolour paintings. The second, larger, section is purely hands-on projects, showing you how to create wonderful watercolour paintings of all kinds of animals from around the world.

The book is an essential absolute beginner's guide to painting animals in watercolour – a great companion to keep by your side while working on your animal projects. Or maybe just a great way to revisit the basics. Here you will find all you need to know about materials, essential mixing and so much more.

The main objective of this book is simple: to give you the confidence, skills, tips and techniques you need to paint your own animals in watercolour.

Happy painting, and let's keep the paint flowing together.

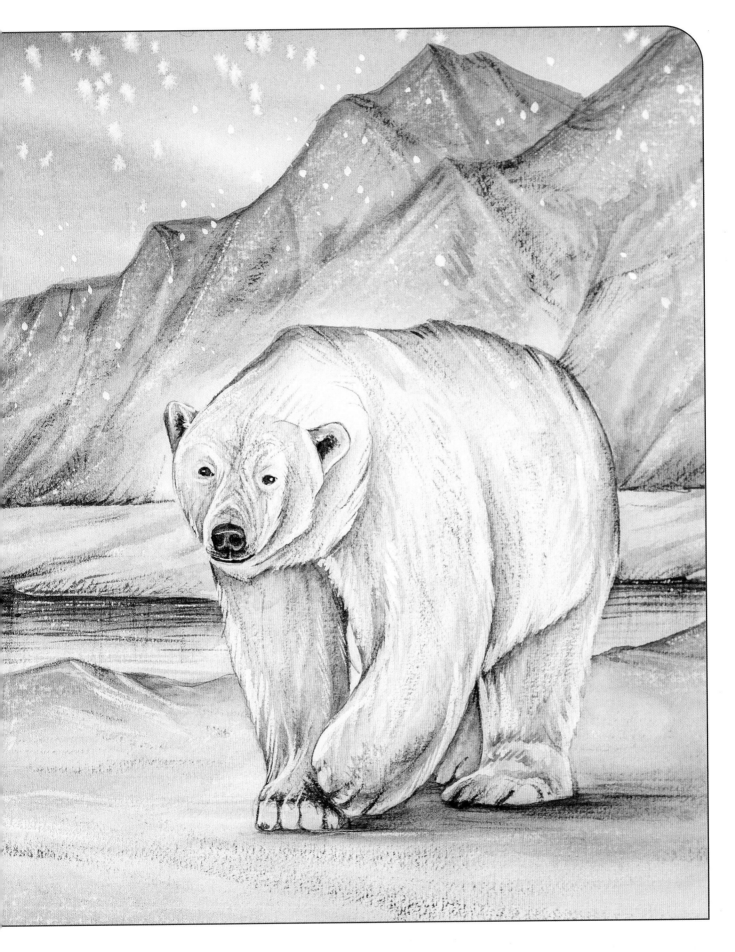

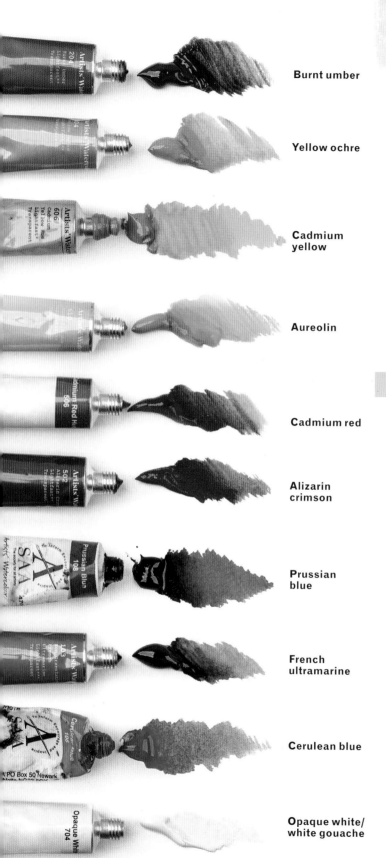

Burnt umber

Yellow ochre

Cadmium
yellow

Aureolin

Cadmium red

Alizarin
crimson

Prussian
blue

French
ultramarine

Cerulean blue

Opaque white/
white gouache

Materials

There are countless materials available to watercolour artists, and it can be a challenge to know where to begin, and which products are best. There is a tendency for new artists to dash out and purchase everything, which complicates matters even further. I have always taught beginners that all they really need is a few primary colours and a handful of brushes. That's it! You don't even need to invest in an expensive palette: a ceramic plate will do. As for a water pot, how about simply using a jam jar? The best advice I can give you is to buy the best paints, brushes and paper you can afford at the time. You really do get what you pay for in the art world.

A question of quality

Watercolour materials come in two qualities: artists' quality and students' quality. Artists' quality is the best quality, using the finest materials and produced to the highest standard. Students' quality is still high but is typically manufactured using synthetic materials. For example, artists' brushes are made from natural hair, while students' brushes are made with nylon bristles. In terms of paints, artists' colours contain gum arabic and, where possible, natural pigments.

Having said all this, it does make a difference working with artists' quality materials, but there are some great quality students' materials on the market. I'm a strong believer in using the best you can afford while learning, as it makes the process much easier.

Traditional paints

Watercolour paints come in two forms: as pans (little square or rectangular blocks of hard paint) and tubes (soft watercolour in a tube). I would recommend tubes to any artist – I love the way in which you can use strong, heavy paints versus light, watery colours. All you do is simply squirt the paint from the tube into the palette, then lift out a little bit of the pigment with your brush and mix it with water.

When the paint from a tube dries, simply add a spot of water to bring the paint back to life again. Watercolour paint never goes off.

Pictured here on the left are common colours readily available on the market that make a great starting palette.

Natural Collection

Over the years I have produced my own range of 'Natural' watercolours (pictured here on the right). These are artists' quality and are pre-mixed, designed to replicate nature, allowing common colours to be used straight from the palette, giving the perfect colour tone each time. Using pre-mixed paints prevents over-mixing and stops you from making too dark a mix. The use of a 'wrong' colour can often throw out your entire painting.

Although these are not essential, and just a basic palette of colours is all you need to enjoy this book, these colours can help you with the process. I explore the use of colour, and the benefits of colour mixing, in more depth on pages 14–21.

Natural grey

Natural violet

Natural blue

Natural turquoise

Natural green

Natural green light

Natural yellow light

Natural yellow

Natural orange

Natural red

Natural brown

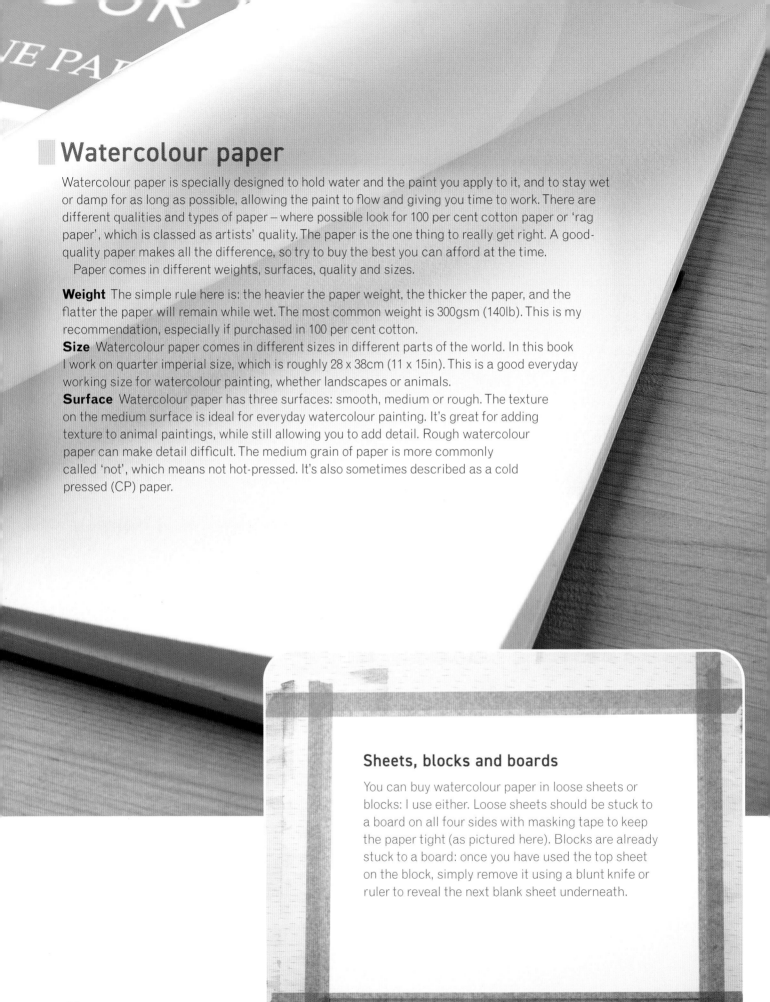

Watercolour paper

Watercolour paper is specially designed to hold water and the paint you apply to it, and to stay wet or damp for as long as possible, allowing the paint to flow and giving you time to work. There are different qualities and types of paper – where possible look for 100 per cent cotton paper or 'rag paper', which is classed as artists' quality. The paper is the one thing to really get right. A good-quality paper makes all the difference, so try to buy the best you can afford at the time.

Paper comes in different weights, surfaces, quality and sizes.

Weight The simple rule here is: the heavier the paper weight, the thicker the paper, and the flatter the paper will remain while wet. The most common weight is 300gsm (140lb). This is my recommendation, especially if purchased in 100 per cent cotton.

Size Watercolour paper comes in different sizes in different parts of the world. In this book I work on quarter imperial size, which is roughly 28 x 38cm (11 x 15in). This is a good everyday working size for watercolour painting, whether landscapes or animals.

Surface Watercolour paper has three surfaces: smooth, medium or rough. The texture on the medium surface is ideal for everyday watercolour painting. It's great for adding texture to animal paintings, while still allowing you to add detail. Rough watercolour paper can make detail difficult. The medium grain of paper is more commonly called 'not', which means not hot-pressed. It's also sometimes described as a cold pressed (CP) paper.

Sheets, blocks and boards

You can buy watercolour paper in loose sheets or blocks: I use either. Loose sheets should be stuck to a board on all four sides with masking tape to keep the paper tight (as pictured here). Blocks are already stuck to a board: once you have used the top sheet on the block, simply remove it using a blunt knife or ruler to reveal the next blank sheet underneath.

Brushes

There are literally hundreds of brushes available to buy, and knowing which are the best is challenging. Let me simplify this for you.

Sable or **natural hair** All sable brushes have super points and great water-holding capacity. For me though, they are too soft. Sable is a natural hair and very expensive, and from an ethical point of view it is not an option for some people. There are two kinds of sable, Kolinsky and red sable, red sable being of slightly lower quality.

Synthetic These are great cost-effective brushes. Each bristle is expertly manufactured to replicate the qualities of pure sable. A great advantage of synthetic is the sturdiness of the brushes: they will last longer than pure sable. The downside is the water-holding properties of these brushes, which is not as good as sable, though still fine for everyday watercolour.

Sable and synthetic mix These are great brushes with roughly three-quarters synthetic and one-quarter sable bristles, giving you the robustness of synthetic with the added water-holding capacity of sable. These are the brushes that I enjoy using most.

Rigger or **branch and detail brushes** These brushes have super-fine tips, named after the rigging on boats, and are designed for fine strokes such as whiskers and claws. To paint really fine lines, load less paint onto the brush, hold the brush near the tip and rest your hand on the paper. My branch and detail brushes use the same concept, just with a larger body – this allows you to have a reservoir of paint, as rigger brushes soon run out of colour.

Lift-out brushes These square, flat-tipped brushes of my own design are for the removal of paint, to create highlights. This is essential in animal painting, and also great for washing out mistakes. Finding a good-quality flat or chisel brush with a sharp tip will give a similar effect, though not all flat brushes will work well. The special lift-out brushes from my range of brushes are designed do this with ease.

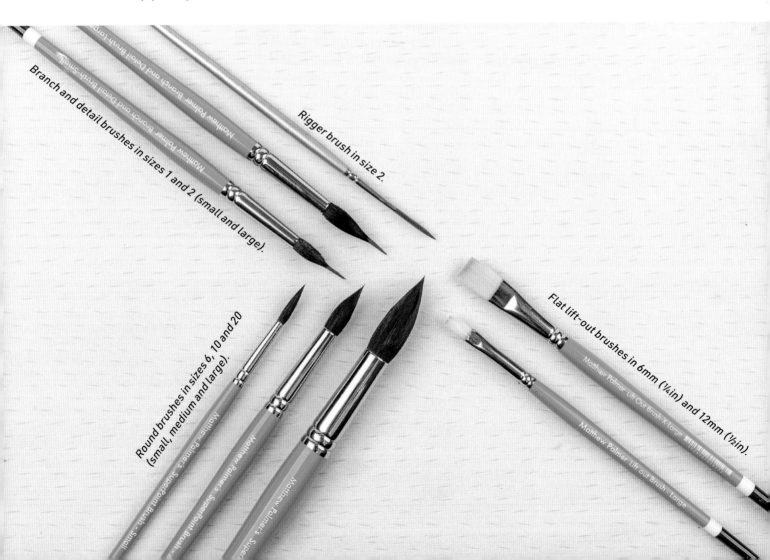

Branch and detail brushes in sizes 1 and 2 (small and large).

Rigger brush in size 2.

Round brushes in sizes 6, 10 and 20 (small, medium and large).

Flat lift-out brushes in 6mm (¼in) and 12mm (½in).

Other materials

Masking tape Used to attach your paper to a board on all four sides, and for various effects such as masking the horizon. I also like to work with a raised board when I'm painting, and popping a roll of masking tape under one end of your board is perfect for this!

Water pot Anything from a glass jar to a professional water pot is fine. It is a good idea to use two pots while painting: one for clean water for mixing and one for just cleaning your brushes.

Mixing palette A good-quality plastic or porcelain palette is best. Try to find one with small areas into which you can squeeze out your paints, allowing you to lift and mix the watercolour.

Salt This works well with watercolour: it can be sprinkled on your wet painting to give a snowflake-style textured effect. Add only a few grains to wet paint and allow two to three minutes for the effect to take place. Brush the salt off when the paint is dry.

Pencil I recommend an HB or 2B pencil for your initial sketch, as the leads are not too hard, so will not scar your paper and can easily be erased.

Eraser We all make mistakes! Putty erasers are made from a soft, malleable rubber and you can shape them to a fine point if required. I also use a plastic eraser (pictured opposite).

Craft knife This is not only good for sharpening your pencil; it is also a great tool for creating special effects. You can scratch out areas of dry paint to give a sparkly effect on water, or a distant silver birch tree.

Fine grain sandpaper Rub this gently over dry paint to give wonderful texture to a mountainside or a grassy meadow.

Kitchen paper This is the artist's best friend! It is essential for dabbing excess paint from your brush and for lifting out colour from wet paint.

Hairdryer Good for speeding up the drying process.

Watercolour paper High-quality paper that will hold the water and paint you apply to it.

Watercolour board Use something sturdy and light to tape your watercolour paper to.

Ruler Perfect for drawing guidelines.

Plastic food wrap Can be used for creating amazing texture effects when combined with watercolours (not pictured opposite).

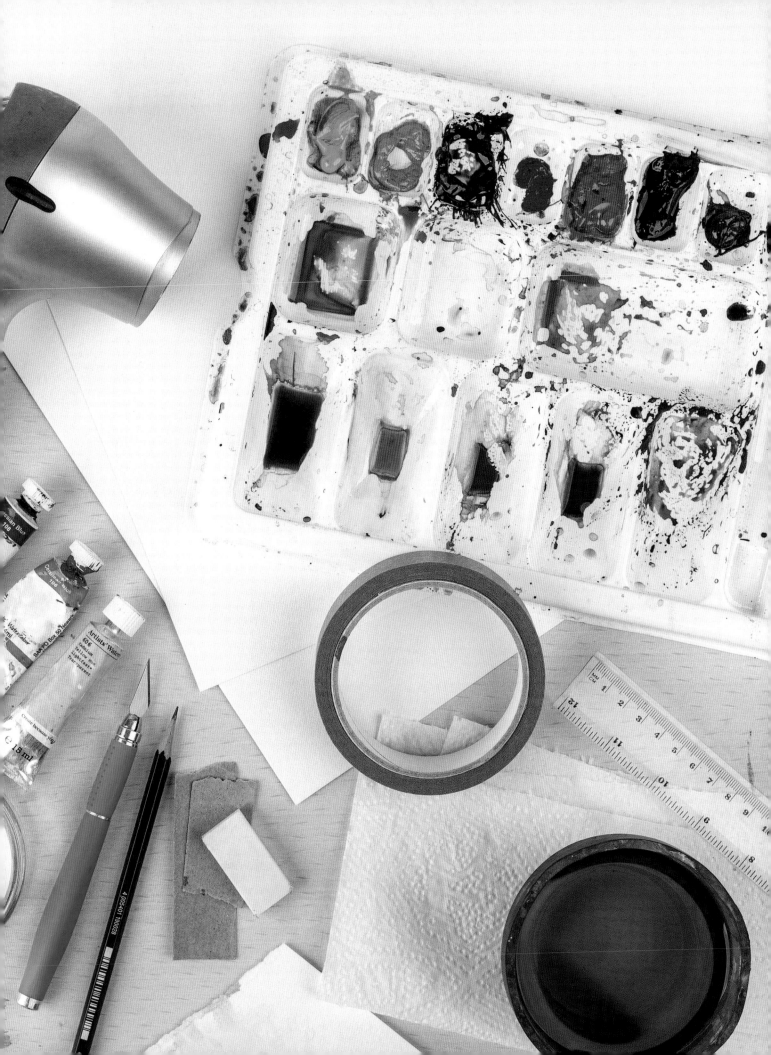

Colour

I have spent years perfecting my colour palette and learning how to achieve the best colour mixes. I have learnt from many years of teaching is that both learners and improvers can struggle to mix colours, so all my common colour mixes – the colours I use on a regular basis – are available to purchase as a stand-alone palette of colours called 'Matthew Palmer's Natural Collection' (see page 19). These are the ones I use all the time in my painting, from landscapes to portraits, animal portraits to still life. These paints are designed to make watercolour painting much easier, and all represent colours that readily occur in nature.

You can, of course, replicate any of these colours using the paints you already have – see page 19.

The essential three

Natural blue The ideal tone for skies and water, this blue contains several blue pigments. Natural blue is more vibrant than French ultramarine and crisper than cobalt blue.

Natural yellow This clean sandstone yellow is used in many animal paintings. It is ideal for animal fur and great in background scenes.

Natural grey Natural grey is pre-mixed from the three primary colours, blue, yellow and red, to give a transparent, 'ready-to-paint' shadow colour that can be applied to any painting.

Useful colours

As well as the essential three colours discussed, there are also a few useful colours that I use regularly. They mix brighter tones and allow a much wider variation of colours in your painting.

Natural yellow light A primary yellow, this transparent, bright shade is great for everyday colour mixing as well as tones and markings on animals.

Natural red A primary crimson-based red, great for mixing colours and often used in skies and animal colourings.

Natural violet A transparent purple with a bluish tone that's great for water, skies and a useful shadow colour – softer than natural grey.

Natural turquoise The perfect seascape and underwater colour. Also useful for birds' feathers and markings.

Natural white This opaque colour, designed to make any area of your paintings sparkle and add highlights, is an essential in animal painting for adding extra details. It is perfect for finishing touches such as fur, whiskers and eyes.

Mixing your own colours

Primary colours – blue, yellow and red – cannot be mixed from other colours. I paint with my Natural Collection range as these are clean, crisp and pre-mixed from primary colours, but if you are mixing your own colours, you will find it useful to have to hand these two sets of primaries. Both sets can be mixed into an even, natural grey.

Set 1: Blue (French ultramarine), yellow (aureolin) and red (cadmium red)

This set will mix bright blues, clean yellows, bright greens, vivid reds and oranges. As an alternative to aureolin, you could try cadmium yellow.

There are many different blues, yellows and reds available to the watercolour artist. The pigment choices shown in the first colour wheel on page 16 (left) are the traditional three, which give you the opportunity to mix dozens of colours. It is always worth your time experimenting with mixes of different colours on the colour wheel.

The second colour wheel on page 16 (right) shows examples of my second set of primary colours: French ultramarine, yellow ochre and alizarin crimson. This increases your primary palette to five colours and provides you the opportunity to blend darker tones without adding a black pigment to the mix (see page 18).

Set 2: Blue (French ultramarine), yellow (yellow ochre) and red (alizarin crimson)

This set will mix darker tones that are great for landscapes: dark olive greens, rusty reds, peach and sandstone.

The primary colour wheel

A good starting point for colour-mixing, and a great exercise, is to paint a primary colour wheel. This shows how the three primary colours are mixed. It helped me greatly in the early days to do this. Over the many years I've been teaching watercolour, I still demonstrate this technique.

The primary colour wheel, set 1

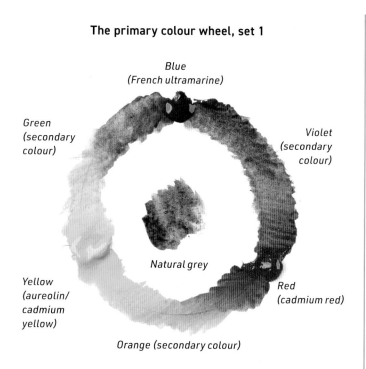

Blue
(French ultramarine)

Green
(secondary
colour)

Violet
(secondary
colour)

Natural grey

Yellow
(aureolin/
cadmium
yellow)

Red
(cadmium red)

Orange (secondary colour)

The primary colour wheel, set 2

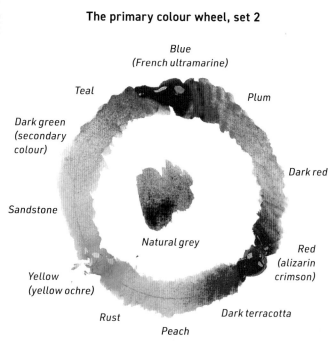

Blue
(French ultramarine)

Teal

Plum

Dark green
(secondary
colour)

Dark red

Sandstone

Natural grey

Red
(alizarin
crimson)

Yellow
(yellow ochre)

Dark terracotta

Rust

Peach

Creating a primary colour wheel

1 Draw a circle on a sheet of watercolour paper (try using a roll of masking tape as a template).

2 Squirt a spot of French ultramarine blue at the top of the circle; aureolin in the lower left arc and cadmium red in the lower right arc.

3 Use a damp size 6 round brush to blend the paints together – the blue towards the red, the red towards the yellow and the yellow towards the blue.

4 Where the colours meet, mix them together: this will result in new – secondary – colours: oranges, violets and greens.

5 Mix your three primary colours in a swatch at the centre of the wheel: this will give you a natural grey. This is the perfect shadow colour and does not contain any black pigment.

Secondary colours

Secondary colours – oranges, purples and greens – are the result of mixing two primary colours. The colour wheels opposite show the secondary colours that appear when the primary colours mix.

Blue + red = violets and purples
Red + yellow = oranges
Yellow + blue = greens

Tertiary colours

Tertiary colours are combinations of both primary and secondary colours.

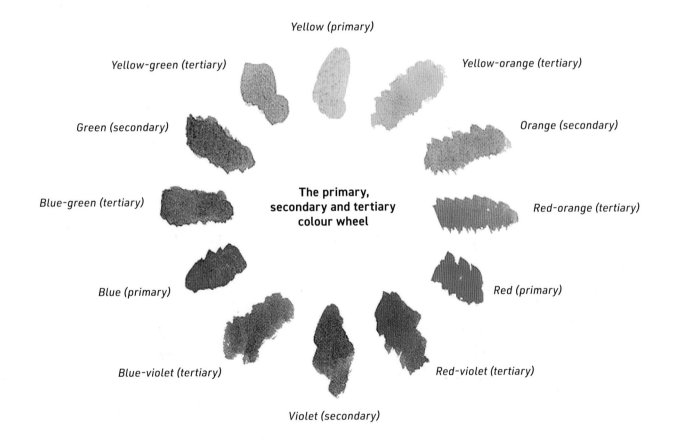

Yellow (primary)

Yellow-green (tertiary)

Yellow-orange (tertiary)

Green (secondary)

Orange (secondary)

Blue-green (tertiary)

The primary, secondary and tertiary colour wheel

Red-orange (tertiary)

Blue (primary)

Red (primary)

Blue-violet (tertiary)

Red-violet (tertiary)

Violet (secondary)

Just add water

Watercolour is simply a case of adding more water to show more of the white paper. The more white you see, the lighter the colour will be. It's helpful to think of it like this: the paper is your white area, and the more water you add, the more white paper you see.

Controlling the amount of water needed can take time, but this is a skill you will soon pick up with practice. Always keep one brushload of water in your mixing palette and add the colour to this. If you want a paler mix, add more water, and if you want a darker colour, add more paint.

To help you learn to control the ratio of water to paint, throughout this book you will see the terms 'extra strong', 'strong', 'medium' and 'pale' alongside the colour mixes, and I have given a percentage to these four main depths of colour opposite to ease the mixing and help you understand how pale or strong the paint should be. Practise mixing the different depths of colour using the percentages opposite before you start work on the projects.

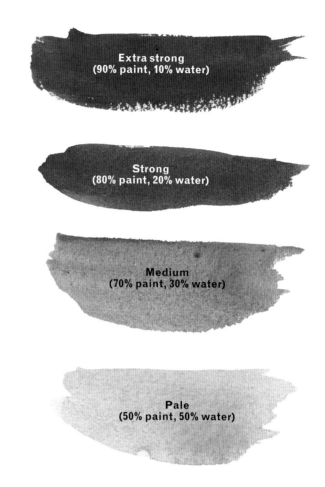

These four swatches show extra strong, strong, medium and pale colour mixes.

Black, white and shadows

In watercolour painting, you will typically use the colour of the paper for white areas, so white paint isn't really needed, although it's great for adding highlights and fine details. We will use it on the projects in this book if you decide at a later stage in your painting to add a light detail, such as animal facial features or fur (see, for example, pages 95–96) in natural white or gouache.

Black or grey – such as Payne's gray – can be too dark and overpower a painting. Natural grey – such as the shade found in my Natural Collection, mixed from the three primary colours – is more of a subtle, transparent shadow colour that recedes, allowing you to lay over any other colour and create perfect shadow tones. See page 28 for more on my perfect shadow mix.

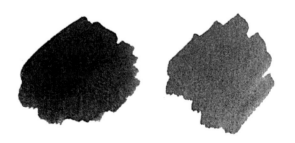

Payne's gray versus natural grey.

Colour comparison chart

Here you can easily see which of the colours in my Natural Collection of watercolours can be replaced with generic colours on the market. Use this chart as a quick reference.

Matthew Palmer's Natural Collection	Alternative generic colour
Natural blue	French ultramarine
Natural yellow	Yellow ochre
Natural grey	Mix 60% French ultramarine with 10% alizarin crimson and 30% yellow ochre
Natural yellow light	Aureolin or cadmium yellow
Natural red	Alizarin crimson or rose madder
Natural violet	Intense violet or dioxazine violet
Natural turquoise	Mix 80% viridian hue with 20% French ultramarine
Natural white	Opaque white or white gouache
Natural green	Mix 70% aureolin or cadmium yellow with 30% French ultramarine
Natural green light	Mix 70% lemon yellow with 30% French ultramarine
Natural brown	Mix 80% burnt sienna with 20% French ultramarine
Natural orange	Mix 70% burnt sienna with 30% aureolin

Colour mix percentages

Here are some useful colour mixes for your watercolour painting, all mixed from the two sets of primary colours (see page 15). French ultramarine, aureolin (or cadmium yellow), cadmium red, yellow ochre and alizarin crimson.

Sandstone and sandy fur
(same as natural yellow)

The perfect light fur colour.

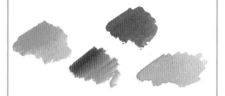

80% yellow ochre + 10% alizarin crimson + 10% French ultramarine

Deep black

For animal markings and dark fur.

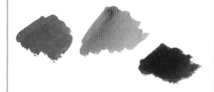

70% French ultramarine + 30% burnt sienna

Deep brown
(same as natural brown)

A strong mix for deep animal tones.

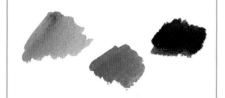

80% burnt sienna + 20% French ultramarine

Average green

For summer foliage or grass, when mixed with lots of water.

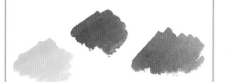

70% aureolin + 30% French ultramarine

Bright green
(same as natural green light)

For spring foliage and sunlit meadows.

70% lemon yellow + 30% French ultramarine

Sea turquoise
(same as natural turquoise)

For seascapes, when mixed with lots of water, and coastal shades.

60% French ultramarine + 40% viridian hue

Sunset orange

Ideal for skies and sunsets.

70% aureolin + 30% cadmium red

Light brown
(same as natural brown)

Good for animal fur and textures.

50% yellow ochre + 30% alizarin crimson + 20% French ultramarine

Snow shadow colour

For dark skies, and snow shadows when mixed with lots of water.

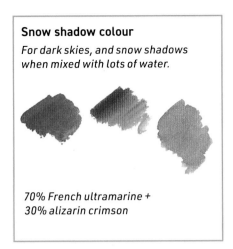

70% French ultramarine +
30% alizarin crimson

Shadow green
(same as natural green)

For dark trees and the shadow areas on trees. Also good for pine trees.

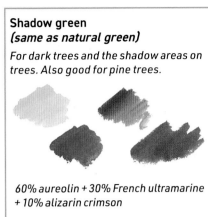

60% aureolin + 30% French ultramarine
+ 10% alizarin crimson

Shadow grey
(same as natural grey)

For shadows, when mixed with lots of water, and skies.

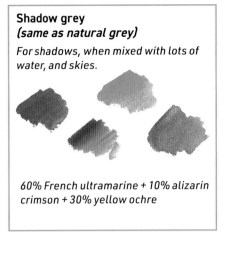

60% French ultramarine + 10% alizarin
crimson + 30% yellow ochre

Additional colours

While the three primary colours will mix most of the shades needed for painting naturalistic watercolours, there are some that cannot be obtained, so it's good to keep a few additional colours in your palette.

Burnt sienna

Great for mixing autumn tones and rusty colours.

Viridian hue

A vibrant green. Use this in tiny amounts to lift another colour. Do not use it on its own.

Intense, or dioxazine, violet

Great for bluebell shades and dusky skies.

Lemon yellow

An opaque yellow that, when mixed with French ultramarine, will give a vivid, opaque green.

Sketching

Although the outlines for the projects in the book are all provided for you, you might like to have a go at sketching your own animals to paint. Drawing animals is not as complicated as it probably seems. In fact, they are one of the easiest subjects to draw using the following system. Most animals start off with basic elliptical or oval shapes, with these shapes representing the head, body and so on. Using a logical shape system really makes sketching animals nice and easy, and is a technique I've been teaching for many years. These rules apply to almost every animal you draw. Here are four examples of the oval and triangular shapes and guide lines in action. Why not practise from your own photographs?

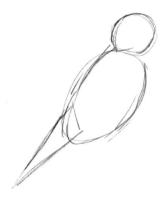 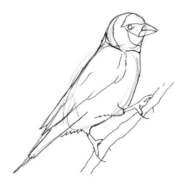

Goldfinch, see page 54.

This goldfinch is made up simply of a small circle for the head, a larger oval for the body and a triangular shape representing the tail feathers.

 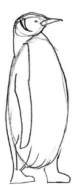 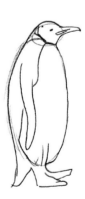

Penguins, see page 50.

Notice how the placement of the oval for the head alters the stance of each penguin.

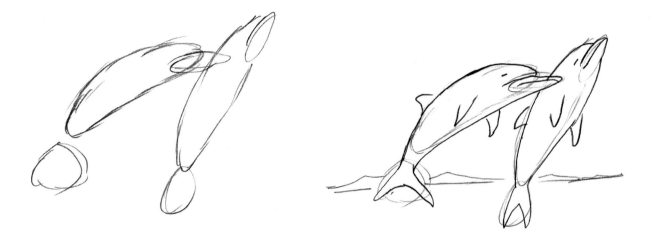

Dolphins, see page 60.

Begin with the basic oval shapes, before adding the finer details such as the fins.

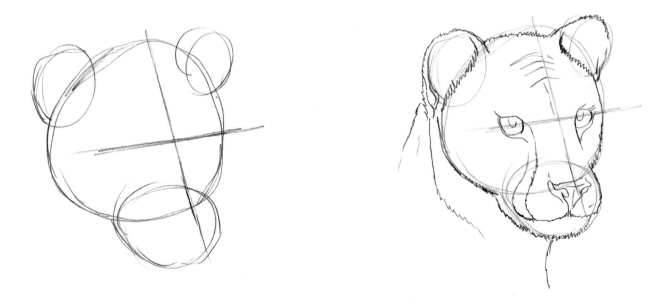

Cheetah, see page 82.

This basic set of two guide lines and the circular shapes make sketching animal portraits straightforward. Draw a vertical line through the centre of the nose, following the angle of the head, and a slightly off-horizontal line for positioning the eyes.

Techniques

Outline 1

These first two exercises – an elephant portrait and a tiger's mouth and nose detail – are great starting points to introduce you to all the essential techniques used in the projects throughout the book.

The elephant painting is divided into sections by technique: wet-into-wet, wet-into-dry, adding shadows, dry brush, lifting out, adding white paint and finishing touches, to take you clearly through the stages involved, and you can easily refer back to these sections. The tiger's mouth and nose (see page 44) shows you how to add facial features, one of those all-important final details to bring some character to your animal portraits.

You will need:

Brushes: sizes 6, 10 and 20 round; 6mm (¼in) or 12mm (½in) flat

Paint colours:
 natural blue
 natural yellow
 natural brown
 natural grey
 opaque white or white gouache

Paint mix:
 warm grey, mixed from
 natural yellow (50%) with
 natural grey (50%)

Other: kitchen paper

▍Wet-into-wet

A wet-into-wet background starts off by wetting the entire page with clean water at least twice. This allows the background to blend and have a soft feathery effect, which is great for skies.

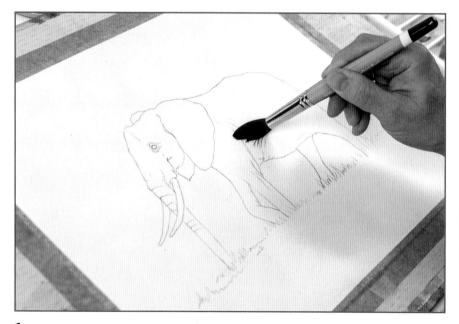

1 Use a size 20 brush and wet the paper twice with clean water.

Tip

When working wet-into-wet, we expect the paper to cockle. When the paper dries it will flatten out and work can continue as normal.

A hairdryer speeds up the drying process, and is not necessary to flatten the paper. Instead, you can leave your paper to dry naturally for 15–20 minutes and the paper will flatten out as it dries.

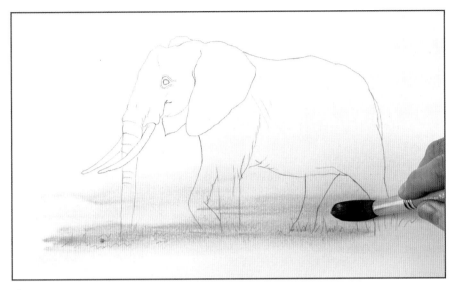

2 Start off by adding horizontal lines towards the bottom of the elephant using the natural yellow. Then, use a size 10 brush with the pale natural brown, and add horizontal streaks around the elephant's feet.

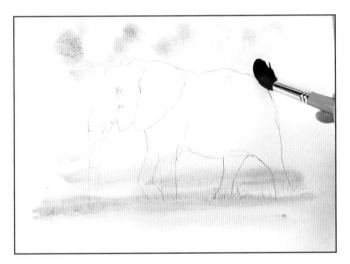

3 Using the pale natural blue on a size 20 brush, lay the brush flat to the paper and twist the brush to create a cloud-like effect. It doesn't matter if the paint goes over the elephant.

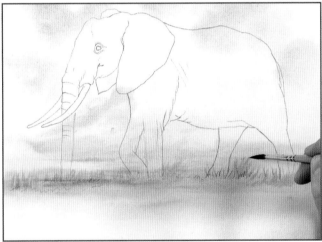

4 Use a size 6 brush to add a few vertical flicks around the base of the elephant to give the impression of tall grass. Use a strong natural yellow for this, and then repeat with a medium-strength natural brown.

5 Leave to dry naturally, or you can use a hairdryer and flatten the paper with a clean hand as you dry it.

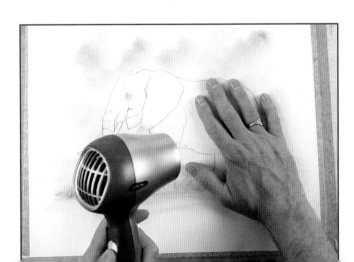

Wet-into-dry

A wet-into-dry wash is working with wet paint on dry paper. Nearly all watercolour paintings are built up using this technique, and this technique is used from this point on, now that the wet-into-wet background is done.

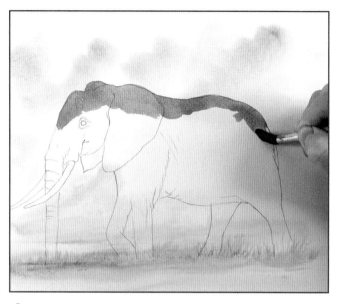

6 Using a size 10 brush and the warm grey mix, start to fill in the top section of the elephant, being careful to paint within your pencil lines.

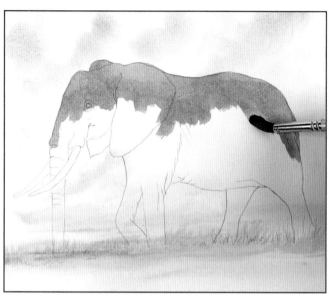

7 Work to about a quarter of the way down the elephant.

8 Clean your brush and remove excess water on kitchen paper by tapping twice – this removes just the right amount of water.

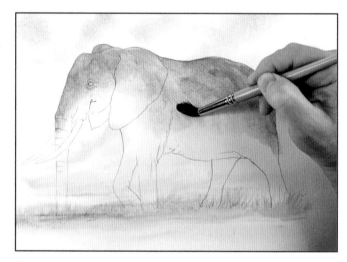

9 Use diagonal brush strokes to bring the colour from the top of the elephant down towards the bottom. Keep the brush moving and keep refreshing the brush in the water to wash off the paint that has been picked up.

Tip
Removing too much water (wiping more than twice on kitchen paper) will make your brush too dry.

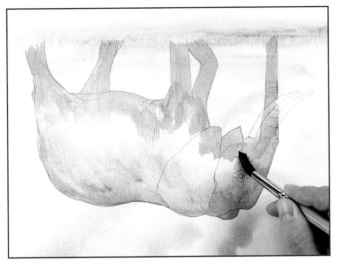 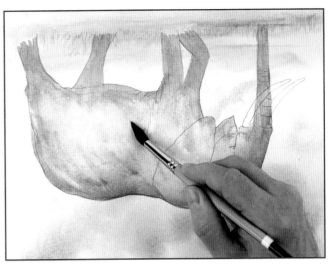

10 Repeat the technique from the bottom of the elephant working up towards the top – try rotating the board and working on the painting upside down. Don't worry if you paint over the tusks, as they will be painted over at a later stage.

11 Continue working until the top and bottom sections meet in the middle.

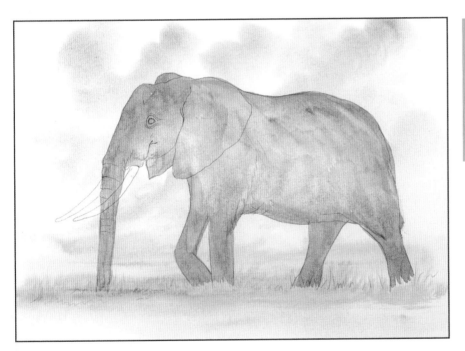

Tip

This technique can take a little bit of practice, but it's a well-used technique throughout all watercolour paintings.

12 Continue to refresh your brush in the water, tapping twice on kitchen paper, and keep blending the top and bottom sections of the elephant as much as you like. The end result is a dry wash of watercolour with a slightly darker top and bottom section. Expect the paper to go a little bit cockled here because a large wash has been applied.

Adding shadow

Once the background wash is dry, this is the exciting part of the painting where we add all the dark shadows. This really makes the elephant look alive on the page.

My essential tips for watercolour blending

- The most important trick is to have a wide enough line to blend away. A thin line doesn't have enough paint to blend.
- The second tip is not to be too dry with your brush. Cleaning your brush and then tapping twice to remove the excess water on kitchen paper is perfect.
- Use the full brush to blend the dark line away with diagonal brush strokes.
- It's important to keep refreshing or cleaning your brush in the water to wash away any paint that has been picked up. Then repeat the two taps on kitchen paper and continue.
- A successful blend should go from a strong colour and completely fade into nothing.

Matthew's perfect shadow mix

Everything has a shadow and it's important not to use a grey made with black pigments. Payne's gray is an example of this, where the black pigment can cause the paint to jump forward and stand out too much.

Natural grey is, however, transparent, allowing the colours underneath to show through, but it also blends away easily and naturally into your painting.

Here's the mix:

60% French ultramarine
10% alizarin crimson
30% yellow ochre

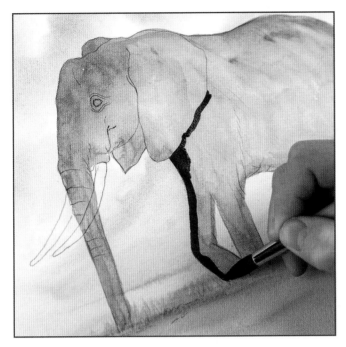

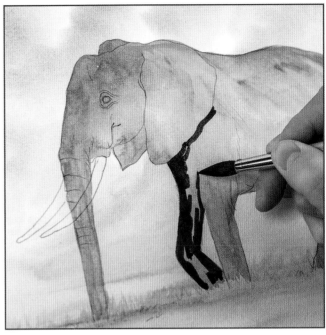

13 Using a strong natural grey and a size 10 brush, start to add some of the large shadows, one at a time. Let's start off with the dark shadow that runs underneath the ear and down the front leg.

14 Continue with the dark shadow, but note that the whole section doesn't need to be filled in as the blending process will connect areas together.

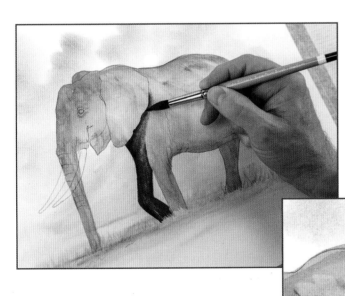

15 Once this area has been blocked in, clean the brush, remove the excess water, and blend the dark area upwards, towards the top of the elephant. It's important to blend the line completely away to nothing, especially where it runs underneath the ear.

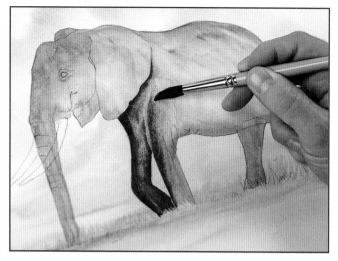

16 Refresh your brush in the water and paint in the shadow on the other front leg, working cleanly along the edge where it overlaps the background. Try to leave a light line just where it meets the opposite leg. Blend away the dark line using the same technique as step 15.

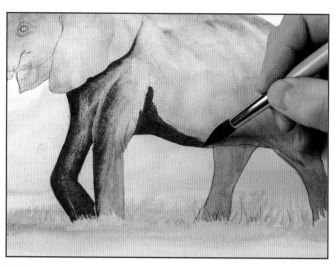

17 Most four-legged animals will have an 'L'-shaped shadow from the front leg working along the base of its belly. Paint this in, and then blend it away into the elephant's belly.

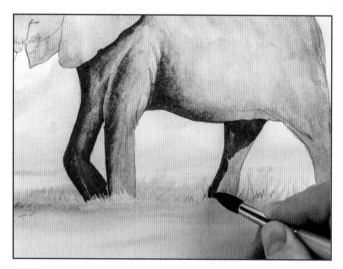

18 Paint in the shadow on the back leg with a block of colour across the top and runs down the left side.

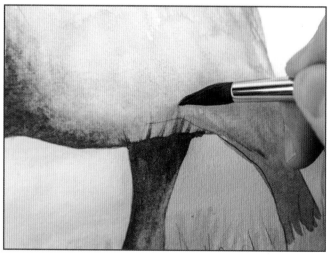

19 Clean your brush, remove excess water on kitchen paper and blend this into the rest of the leg, then add a few creases or folds to the belly with little upwards strokes.

Tip

Often the damp brush that you have for blending can be used to add creases and folds to an animal's flesh. Simply drag the damp brush from the edge, working towards the area where the texture is required.

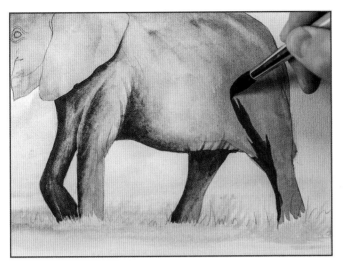

20 Add a shadow to the closest rear leg, running down the left edge and upwards to start to create the muscular form of the hind leg.

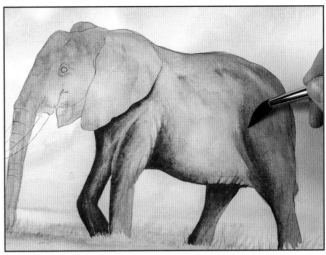

21 Use a clean, damp brush to blend this shadow towards the top of the elephant and on both sides towards the elephant's belly.

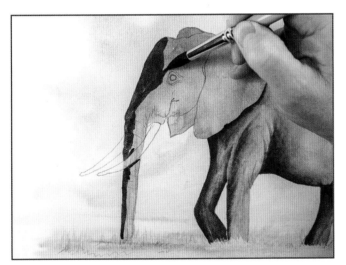

22 Add a strong shadow down the left side of the trunk, working slightly underneath the tusks. I'm still using a size 10 brush, but feel free to use a smaller brush if it's easier. Paint the shadow all the way to the top of the head, slightly curving over the brow and widening as it covers the top of the head.

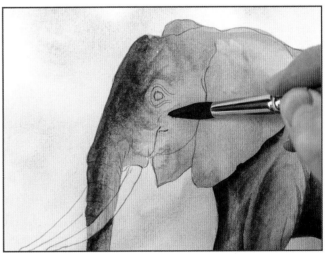

23 Use a damp brush to blend the shadow across the face, leaving a light surround to the eye.

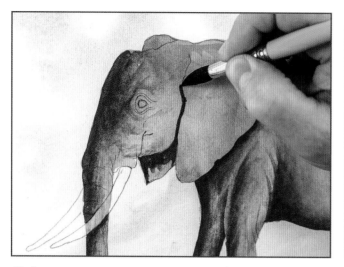

24 Add a final large shadow on the back ear which runs cleanly along the base of the elephant's head and up the side of the large ear. A smaller brush may be more comfortable at this point.

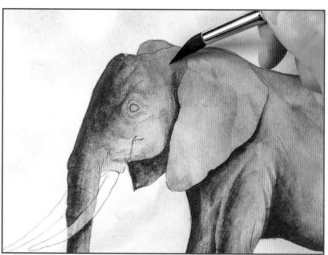

25 Blend in these lines – down towards the bottom of the ear and into the head. Take care to blend the top line completely away into the head.

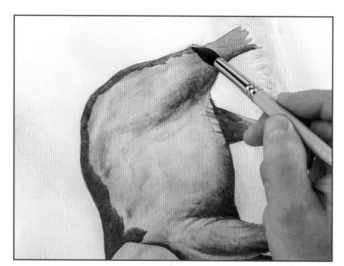

26 Using a medium grey, and rotating the board if more comfortable, add a shadow across the back of the elephant, carefully painting from the ear and gradually tapering off as the line goes down the rear of the elephant.

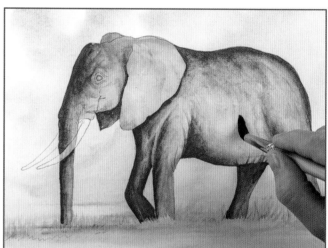

27 Using the same blending technique, blend this line completely down towards the bottom of the elephant, taking care to add some contour lines following the curve of the elephant's belly.

Tip

When using a strong grey, you don't need to worry about finishing all the blending while the paint is still wet. Adding water reactivates the paint to make it blend easily. This means you can add several lines of paint, and go back and blend them one by one afterwards.

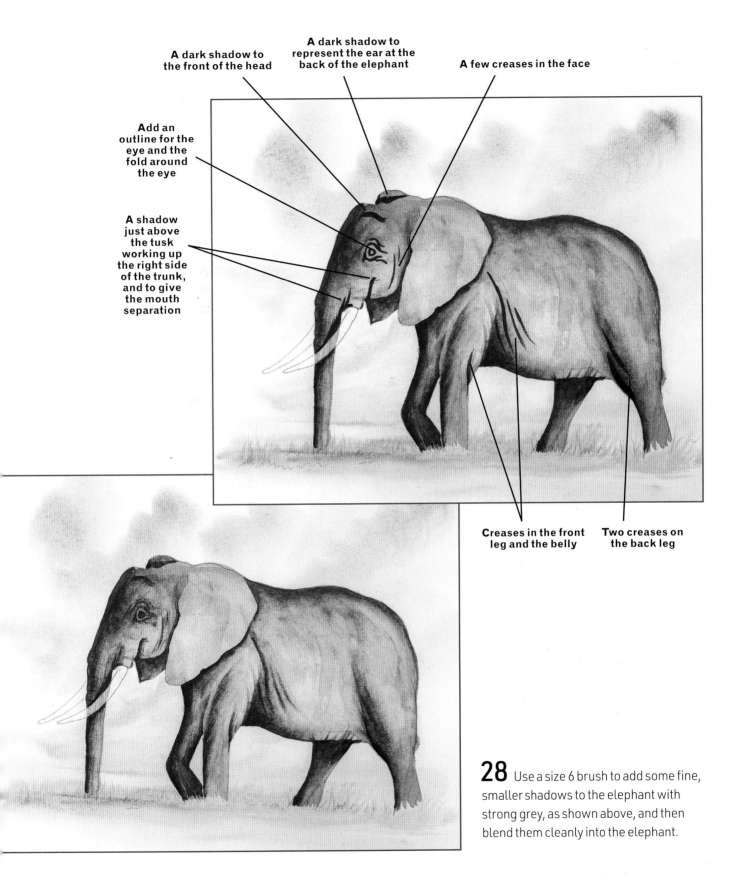

A dark shadow to the front of the head

A dark shadow to represent the ear at the back of the elephant

A few creases in the face

Add an outline for the eye and the fold around the eye

A shadow just above the tusk working up the right side of the trunk, and to give the mouth separation

Creases in the front leg and the belly

Two creases on the back leg

28 Use a size 6 brush to add some fine, smaller shadows to the elephant with strong grey, as shown above, and then blend them cleanly into the elephant.

Dry brush

Dry brush is a texture-adding technique used in almost every single animal painting I've ever done. The trick here is to have just the right amount of paint on the brush, splay the bristles and lightly skim the paper. Hold the splayed brush horizontally to add texture, or vertically to give finer lines.

Tip

It's worth practising this technique on a piece of scrap paper, but the basic technique is to drag the splayed bristles over the elephant following the shape of the animal, for example the way the belly bulges forward.

29 Using a strong natural grey and a size 6 brush, dab the brush on kitchen paper then splay the bristles as shown.

30 Add some dry lines from the edge of the large ear, working towards the head.

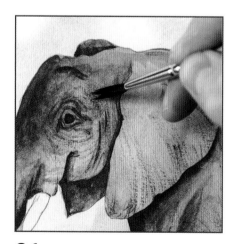

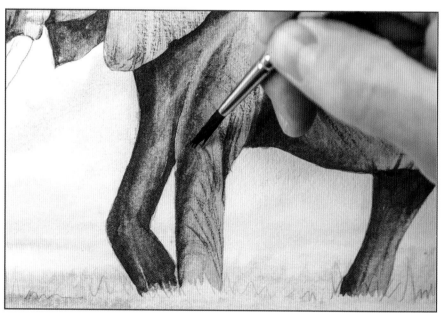

31 Add some of the same dry lines, following the curve of the head, being careful to work around the eye, almost like a knot on a piece of wood.

32 Add some dry lines to the main belly of the elephant, being careful to follow the contour and creases. The folds can be intensified with this dry-brush effect. These dry lines also feature quite heavily on the legs, again following the contour to create the three-dimensional shape and the curvature of the legs.

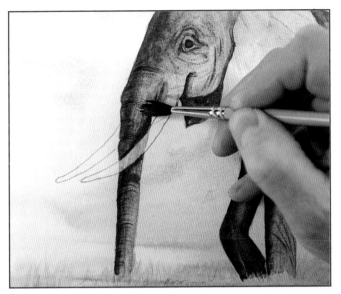

33 Work on the trunk with the splayed brush, adding texture all the way up towards the head.

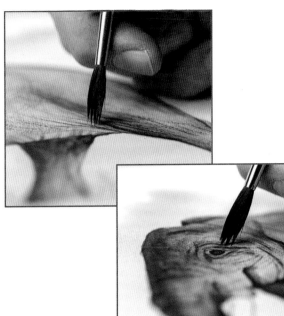

34 Hold the splayed brush almost vertically to add some more precise dry lines.

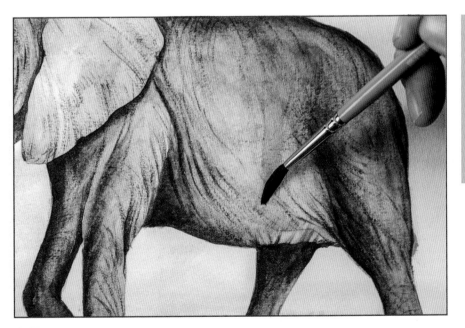

35 Add dry lines over the belly, following the curve of the animal. This is great for adding some of the wrinkles to the elephant.

Tip

If you put too many dry lines on your painting and it starts to look a little bit too textured, use a damp brush, remove excess water on kitchen paper first, and glaze over the top to soften any harsh lines.

Lifting out

Lifting out is a highlighting technique not widely used by many artists. For me it came naturally when learning how to paint animals many years ago. It always happens towards the end of the painting and can add so much life and muscular form to animals.

The secret to lifting out paint is to use a high-quality flat brush or a special lift-out brush. Pick up some water on your brush and gently use your fingers to remove excess water, as shown to the right. Note that pale colours cannot be lifted out as the paint isn't strong enough for the effect to work.

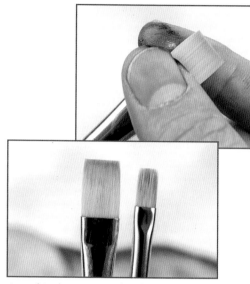

6mm (¼in) and 12mm (½in) flat lift-out brushes.

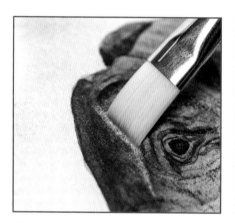

36 Start off by using the tip of a 12mm (½in) square brush to scrub the paint off the paper. And then use clean kitchen paper to give a firm dab – this removes the colour from the painting. Repeat the effect for twice the highlight.

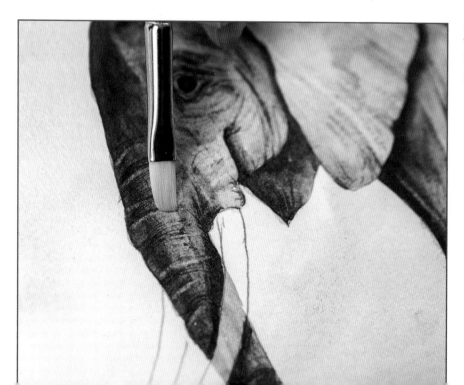

37 Use a 6mm (¼in) flat brush to highlight the trunk with small horizonal lines.

Around the eye

The top of the head

**Diagonal lines in the ear
pointing towards the head**

**Along the top of
the back**

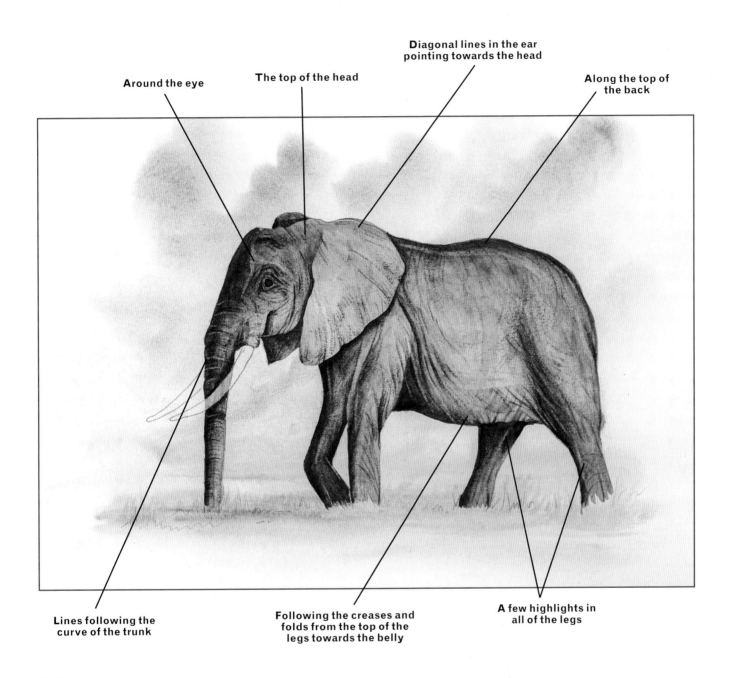

**Lines following the
curve of the trunk**

**Following the creases and
folds from the top of the
legs towards the belly**

**A few highlights in
all of the legs**

38 To complete the highlights, use the lift-out technique on further areas of the elephant,
as shown above.

Adding white paint

Opaque white paint is great for putting finishing touches to any animal portrait. The secret to using white paint is to add just a tiny amount of water. Too much water and the white will disappear once dry. Each white paint is different so testing is essential. The paint needs to be fresh from the tube.

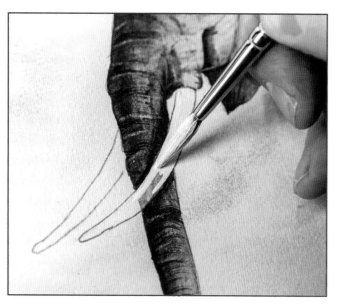

39 Carefully paint in the tusks with white paint on a size 6 brush. Allow this to dry.

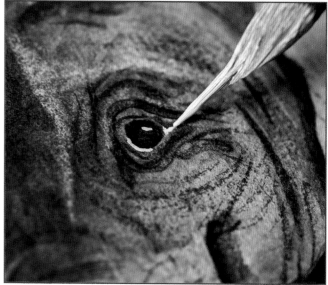

40 Add a tiny highlight to the eye to give it a life-like effect. Add thin lines around the bottom edge and corner of the eye. Use a size 1 rigger or small branch and detail brush.

41 Add further white here and there across the animal to create a three-dimensional effect. Apply the paint using quick, light brush strokes that taper away at the end of each stroke.

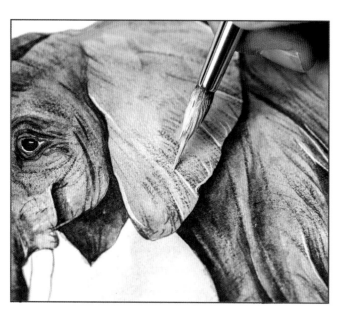

**The curve of
the trunk**

**Around the
edges of the ear**

**Add lighter parts of the creases
and folds in the elephant's skin**

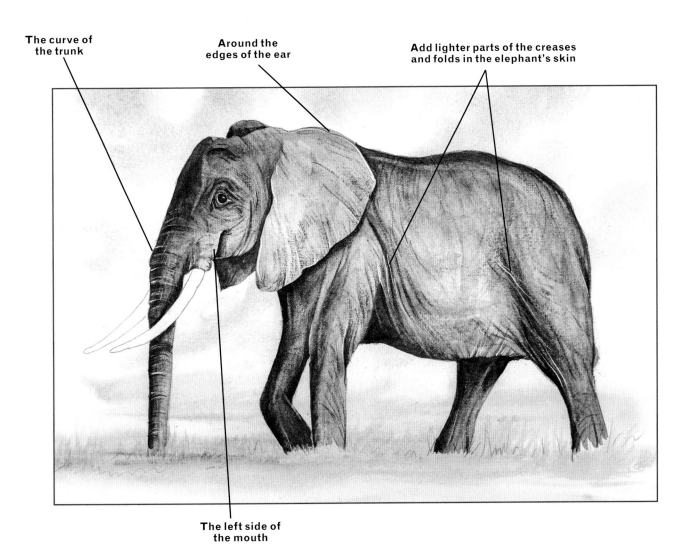

**The left side of
the mouth**

42 Add some further lines in white paint, as shown.

Finishing touches

It's so important to finish off your painting, as those last little details always complete it. So many times I hear stories of learners and improvers not finishing their painting because it's not going the way they expected it to. Not every step of the painting looks right, so it's important to say – always finish a painting even if you feel it's not going the way you expected! I guarantee it is the final stages of a painting that bring it all together, and it will look a hundred times better when it's complete. Trust me, I'm an artist!

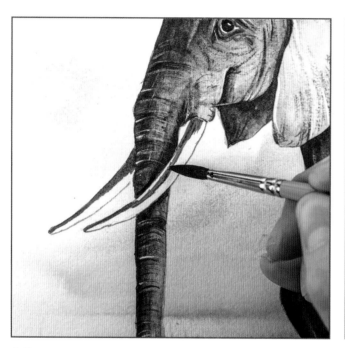

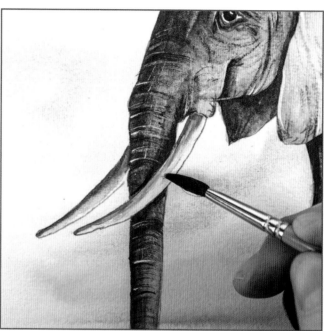

43 Add a line of strong natural grey paint down the centre of the tusk where it overlaps the trunk. It doesn't matter if you work over some of the white paint.

44 Using a clean damp size 6 brush, carefully blend the grey towards the base of the tusk to give a three-dimensional shadow.

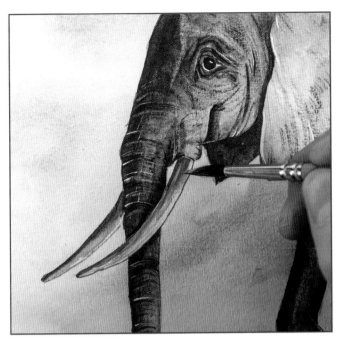

45 Add a tiny amount of strong natural yellow using a dry brush. This will give a more natural-looking effect to the tusks.

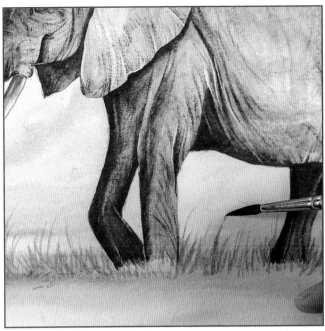

46 Using the pale natural brown on the tip of a size 6 brush, add some tall grasses painted very quickly around the ground.

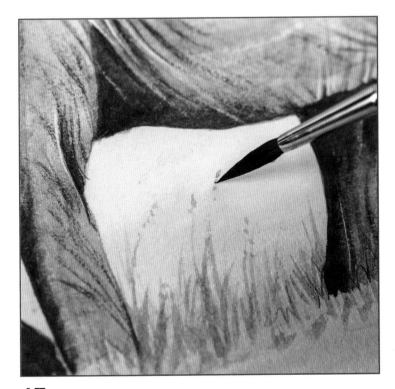

47 Add a few spots to the tops of the grasses to give natural variation.

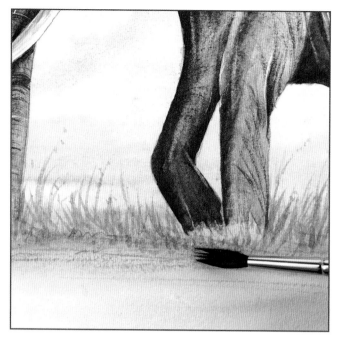

48 Add a few horizontal dry-brush lines with the splayed bristle technique (see step 29 on page 34) to give a little texture to the foreground.

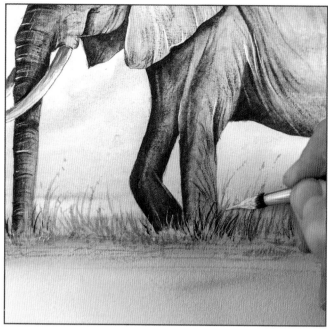

49 Use a rigger or a branch and detail brush to add a few darker blades of grass in natural brown, and do the same with the white paint, especially where the ground overlaps the dark shadows of the elephant.

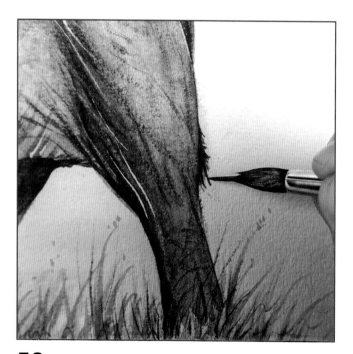

50 Using natural grey on a rigger or branch and detail brush, add a hint of the elephant's tail from behind the back leg.

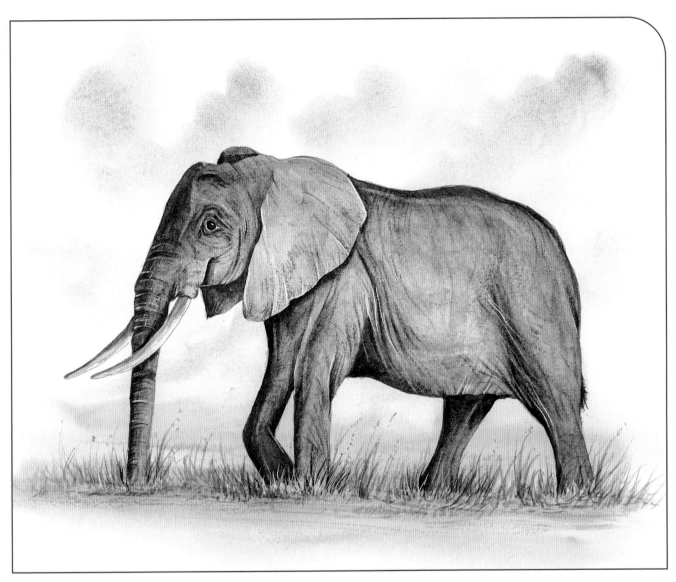

The finished elephant.

Adding facial features

The facial features really make an animal come to life. Here we will learn how to paint two key areas – the nose and mouth – and learn some wonderful watercolour techniques along the way. In this exercise you will develop the techniques learned in the previous elephant portrait, and put your new skills into practice.

When you're ready to begin, transfer the outline to your paper and use a size 20 brush to wet the entire page twice.

Outline 2

You will need:

Brushes: size 6, 10 and 20 round; rigger size 2

Paint colours:
 natural yellow light
 natural red
 natural blue
 natural grey
 natural orange
 opaque white or white gouache

Paint mixes:
 warm orange, mixed from natural yellow light
 (70%) with natural red (20% paint) and a touch
 of natural blue (10% paint)
 peach, mixed from natural red (80%) with
 natural yellow light (20%)

Other: kitchen paper

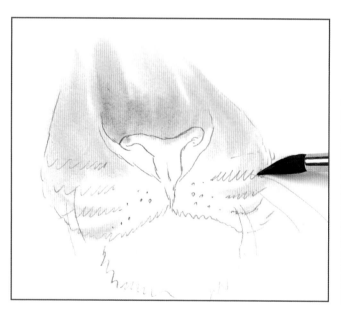

1 Use a size 10 brush with natural orange. Paint in the fur, starting from the top of the nose and working up towards where the head would be, then the jowls. Add some little flicks to represent stripes.

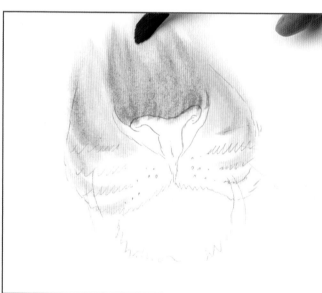

2 Use the warm orange to paint in a darker ridge on the top of the nose and a couple of darker stripes on the left and right sides of the mouth. For any hard lines, simply clean the brush well, remove excess water on kitchen paper, and blend upwards to mix with the orange.

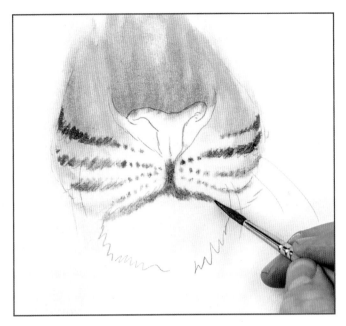

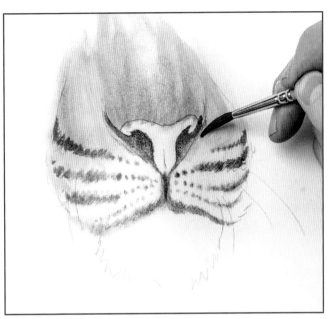

3 Using a size 6 brush and a strong natural grey, paint in the stripes around the mouth area. Working over the damp paper allows the paint to spread and bleed, giving a natural fur-like effect.

4 While the paint is almost dry, paint dark shadows inside the nostrils and feather the outside edges. Feathering creates a soft edge by lightly skimming the page with your brush.

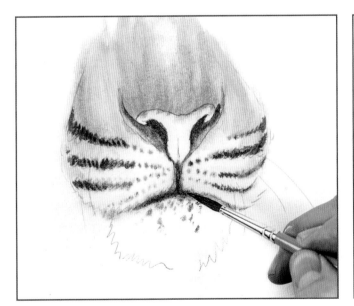

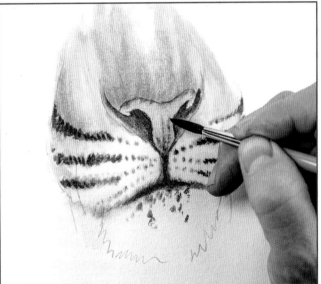

5 Add a few spots to the bottom section of the mouth. If the paper is too dry, lightly scuff the surface of the paper to give a more natural stroke. Revisit the dark areas as the paint is starting to dry, going over the inside of the nostrils and along the mouth. Allow to dry.

6 Use the peach paint mix and a size 6 brush to block in the fleshy part of the nose. While this is still damp, use the tip of your brush to paint a thin line down the centre of the nose using the strong natural grey, and some darker markings towards the bottom of the nose. Allow the paint to spread and bleed into the peach paint.

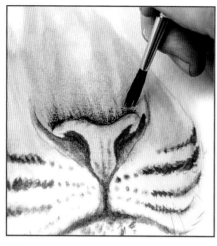 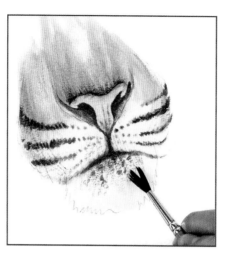 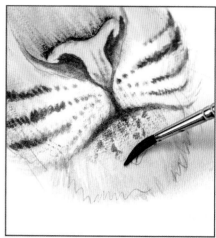

7 Using the same strong natural grey, splay the bristles of your brush and paint a darker edge with small upwards brush strokes along the top edge of the nose. Spend more time working on the edge, where the nose meets the fur, to create more of an outline along the nose.

8 Use the same dry brush with splayed bristles to add contour lines downwards from the mouth, following the shape of the mouth, nose and jowls.

9 Using pale grey on a size 6 brush, add some long hairs underneath the tiger's mouth. Paint these very quickly in a loose fashion. Add water to the brush, removing excess on kitchen paper, to blend these lines upwards towards the mouth.

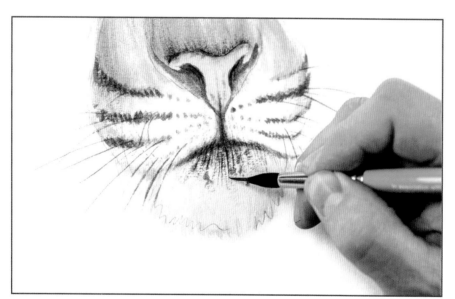 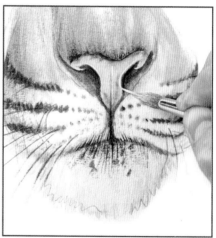

10 Using a strong natural grey with a rigger brush, remove any excess paint on kitchen paper, and add some slightly darker areas inside the nostrils, over the stripes and the whiskers, adding further small whiskers around the mouth.

11 Using a rigger brush with an opaque white, paint in some hairs along the top of the tiger's mouth. Add a little bit of white to the edge of the nose where it meets the nostril, and a thin line down the centre of the nose – this really brings the area into three-dimensions.

Tips

When painting whiskers, flick the brush away at the end of each whisker to give a natural taper.

If we were to paint the entire animal, white paint would be used for the whiskers, but in this exercise it makes sense to use strong natural grey.

See page 38 for more on using white paint.

The finished tiger's mouth and nose.

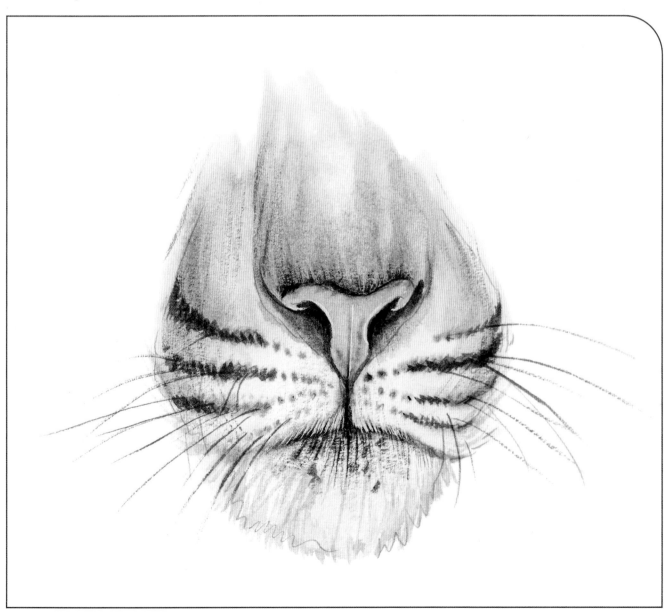

The projects

This is where the book gets really exciting! Now you are going to paint complete animal paintings ranging from a portrait of a cheetah, to an elegant sea turtle, a colourful parrot and a cute panda chewing bamboo.

There are three simple projects to start with – penguins, a goldfinch and a pair of silhouetted dolphins – then six longer projects, each building your skills throughout the book. Each painting is broken into steps, showing every brush stroke and detail. Each project has its own pull-out outline for you to trace if needed, taking away the fear of the white page.

You'll see at the start of each project that I show you my paint palette as it looks when I start working on each painting. I tend to mix most of the colours before I begin, although sometimes I add more as I work, meaning the palette doesn't always include every mix. Please refer to the 'You will need' list in each project for a definitive list of colours used.

Using the outlines

On the following pages are the outlines for each project, including those within the techniques section (pages 24 and 44). All outlines are printed at full size and are designed to fit a standard sheet of quarter imperial or A3 (42 x 29.7cm/16½ x 11¾in) watercolour paper.

Carefully remove each outline from the book. You can transfer the outline to your watercolour paper by using a soft pencil to scribble over the back of the outline, then trace onto your watercolour paper. It is also a good idea to reinforce the outline once it is on your watercolour paper, as your brush may wash off some of the pencil when you begin to paint. Alternatively, use a bright window to trace the outline onto your watercolour paper. When you are drawing for a painting, only the basic outline is required.

As well as being provided in the book, the outlines for the projects are also available to download free from the Bookmarked Hub: www.bookmarkedhub.com. Search for this book by title or ISBN: the files can be found under 'Book Extras'. Membership of the Bookmarked online community is free.

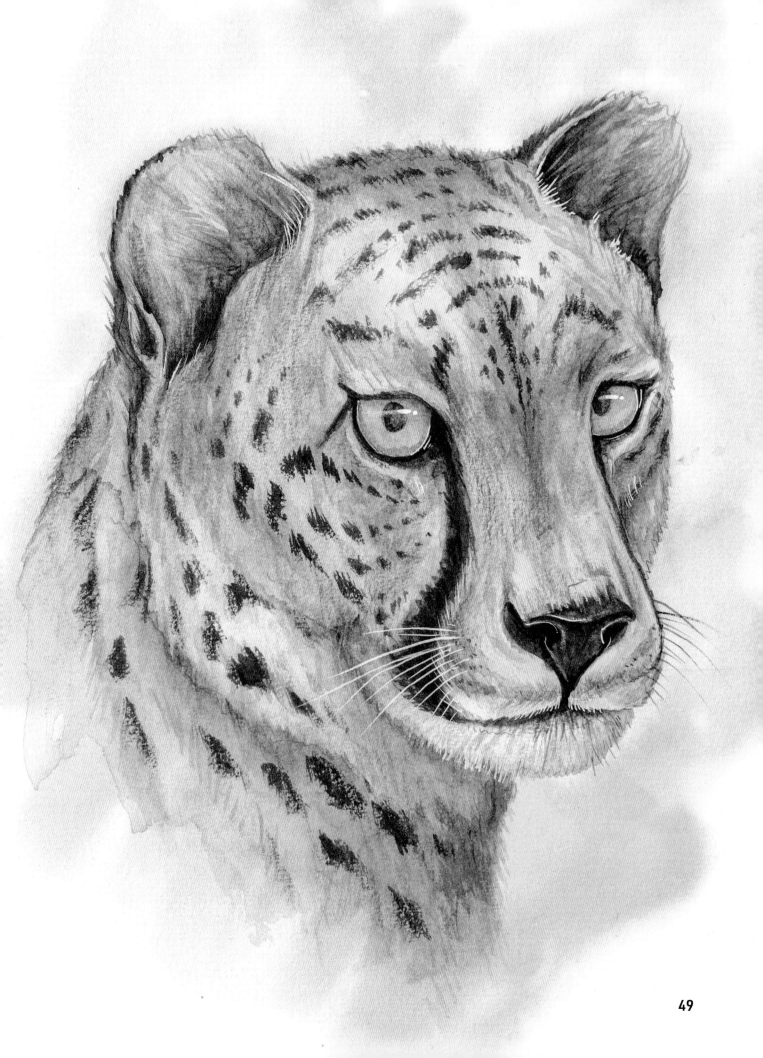

Penguins

This pair of emperor penguins is a great first project. Just painted against a white background with subtle grey shadows, this project will teach you how to paint with strong colours, add facial detail and use the lift-out technique.

When you're ready to begin, transfer the outline to your paper and use a size 20 brush to wet the entire page twice.

Outline 3

You will need:

Brushes: size 6 and 20 round, 6mm (¼in) or 12mm (½in) flat

Paint colours:
- natural grey
- natural yellow light
- natural red

Paint mixes:
- orange, mixed from natural yellow light (70%) and natural red (30%)

Other: craft knife, kitchen paper

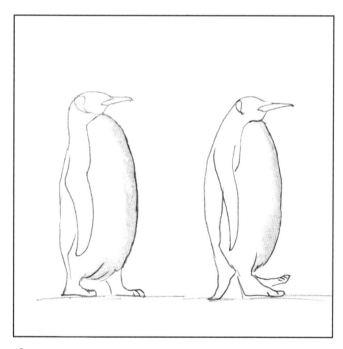

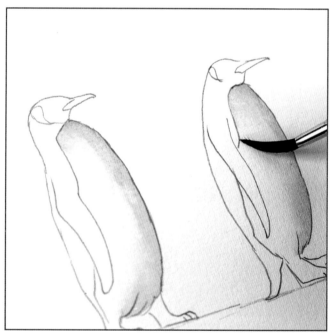

1 Using a size 6 brush and the pale natural grey, paint a wide line all the way down the breast of each penguin, working downwards. Clean your brush well, wipe on tissue to remove the excess water, and then use water to blend the grey line into the white.

2 Pick up the strong natural yellow on your size 6 brush and add this to the top of the breast on both penguins. Clean your brush, wipe it almost dry and blend the yellow downwards.

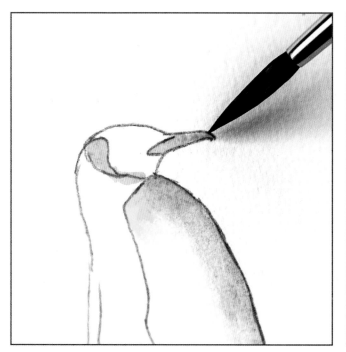

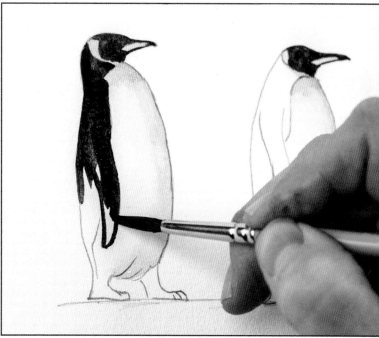

3 While the yellow is slightly damp, add some orange mix on the top of the yellow, allowing the paint to spread and bleed. Add orange to the beaks and to the left of the head. Allow to dry.

4 Use strong natural grey to paint both heads. Carefully add a thin line underneath and on top of each beak and down the back of each penguin, being careful to paint cleanly up against the orange marking on the head.

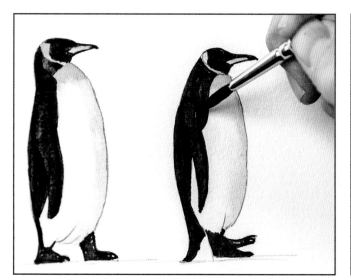

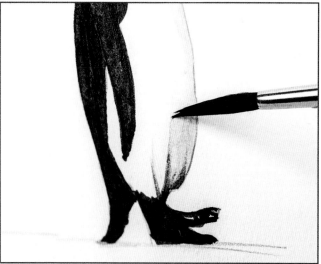

5 Continue to work down towards the tail of the penguins, painting the feet in the same strong grey. Add a dark line to the right side of each flipper, and then a few grey shadows on the feet and tail. Allow to dry.

6 Use a new medium mix of natural grey, with the same brush and add a few shadows to the penguins' bodies. Use a damp brush to blend these lines upwards towards the top of the penguin.

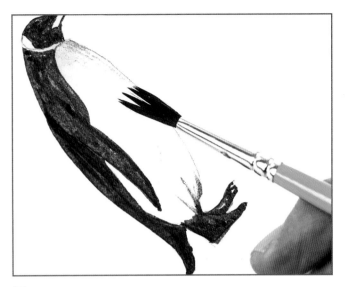

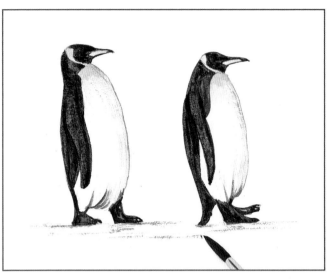

7 Using this same grey, load the brush, remove excess paint on kitchen paper and splay the bristles with your fingers. Very gently skim the surface over the white part of the penguin.

8 Use strong grey to add a few horizontal lines as shadows around the base of the penguins.

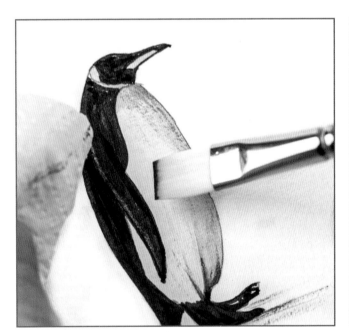

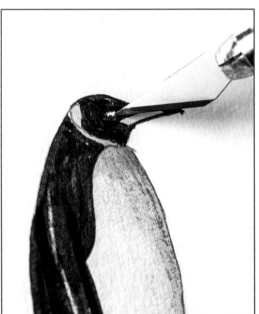

9 Wet a 6mm (¼in) or 12mm (½in) flat brush and remove excess water by gently squeezing the bristles through your fingers. Add some highlights using the tip of the brush to lighten the left side of each penguin's wing. Dab the paint off with dry kitchen paper.

10 Finally, use the tip of a craft knife to scratch in the eye on each penguin. Don't be afraid to dig deep to scuff the paper slightly here.

The finished painting.

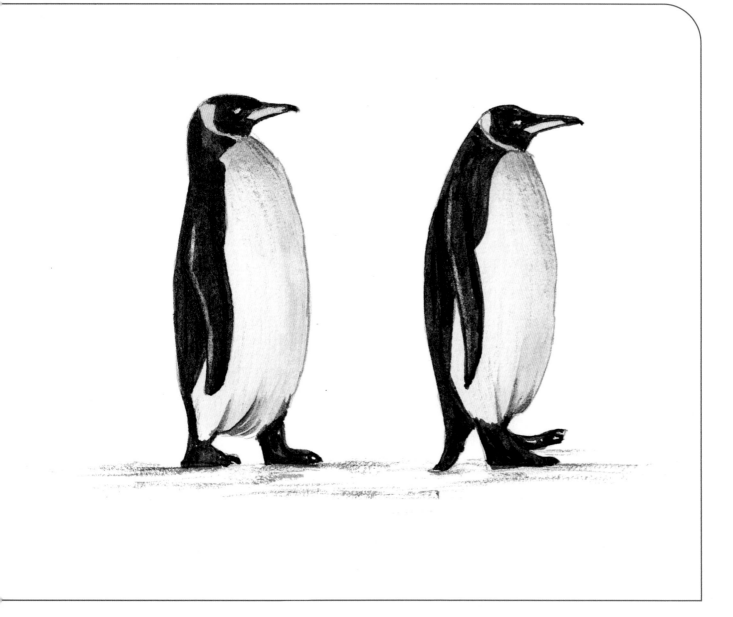

Goldfinch

We're starting to build up more a detailed painting with this goldfinch. With close-up detail of the eyes and beak, this makes a great little project for learning to add more shadows and detailed markings to your watercolour painting.

When you're ready to begin, transfer the outline to your paper and use a size 20 brush to wet the entire page twice.

You will need:

Brushes: size 6, 10 and 20 round, size 1 rigger

Paint colours:
 natural yellow
 natural yellow light
 cadmium red
 natural grey
 opaque white or white gouache

Other: kitchen paper

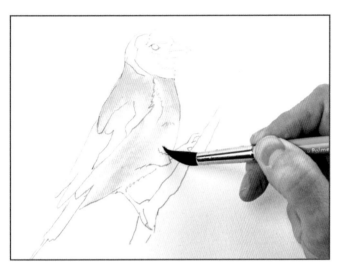

1 Using a size 10 round brush and natural yellow light, start to paint in some of the bird's body, working neatly inside the pencil edges, and blending each section as you go.

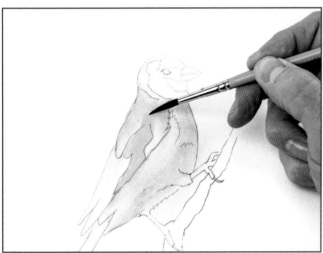

2 Change to a size 6 brush and add medium-strength natural yellow light to paint in the bright yellow on the wing, ensuring the colour is nice and vivid. Lightly blend this upwards.

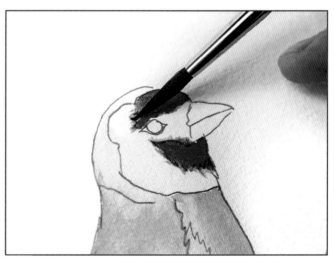

3 Use the cadmium red to add the bright area around the beak, still working with a size 6 brush. Clean your brush really well and gently feather the edges of the red areas.

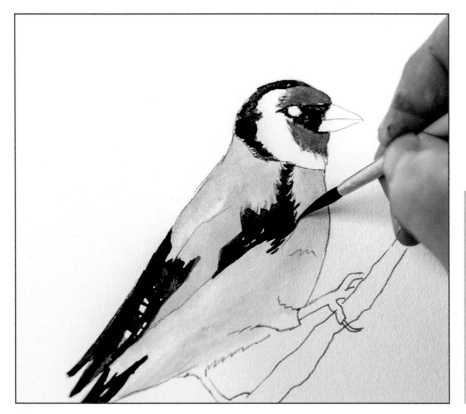

Tip

Try to leave a few white areas at the tip of the wing and tail feathers for a natural look. Once the dark paint has been applied and left to dry, use a clean size 6 brush, wiping almost dry on kitchen paper, and lightly feather the edge of these areas.

4 Use strong natural grey and start to add the dark areas around the head and the wings. Don't be afraid to use strong paint here – just wipe your brush on the side of the palette to remove any excess colour. Blend these dark areas until they have a soft feathery edge. Work carefully to stay within the body of the bird, and drag the grey paint to follow the contour of the bird's body.

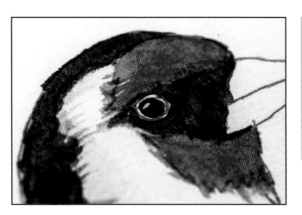

Tip

If you don't manage to leave a clear white ring around the eye, an opaque white paint can be used at a later stage to highlight the eye.

5 Pick up an extra-strong mix of natural grey with a tiny amount of water on a round size 6 brush with a good point. Paint in the eye, being careful to leave a white outline all the way around and a tiny white spot towards the top.

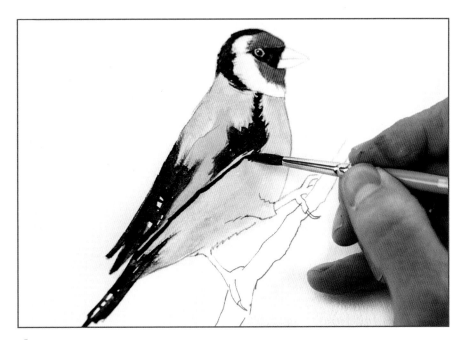

6 Use the same strong grey to add a bold shadow underneath the wing, leaving a slight gap as it meets the grey areas on the wing. Make sure this line is about the same width as your brush, and blend away smoothly, downwards into the bird.

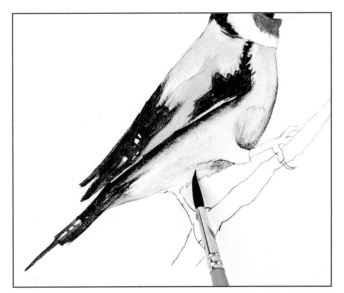

7 Clean the brush, wipe off the excess water on kitchen paper, and blend this area down towards the bottom of the bird. Make sure that the top area of paint disappears towards the top of the bird. Keep refreshing your brush in the water, removing the excess on tissue, until the grey line is completely blended away smoothly.

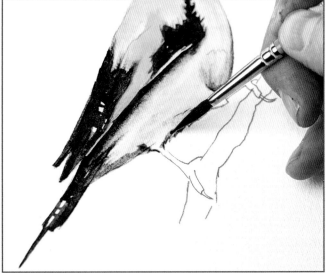

8 Add further shadows to the bird – along the breast, and on the underneath of the bird. Blend in these lines, gradually tapering the lines until they disappear.

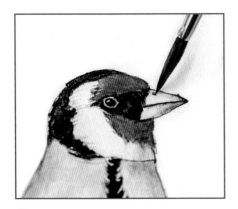

9 Use strong grey to add a thin outline around the top and bottom of the beak. Add a tiny amount of natural yellow to add a slightly warm colour to the beak. Add a tiny spot for the nostril.

10 Paint in the feet. Mix natural grey (50%) and natural yellow (50%) with plenty of water, and simply outline each foot. Clean the brush again, and blend this outline area towards the centre. This will leave a light area of paint.

11 Using a size 6 brush, use strong grey to first add a shadow to the claws on both feet. With a clean brush, lightly feather this line away into the claw to create a curved effect. Add a few wrinkles to the claws using the same grey.

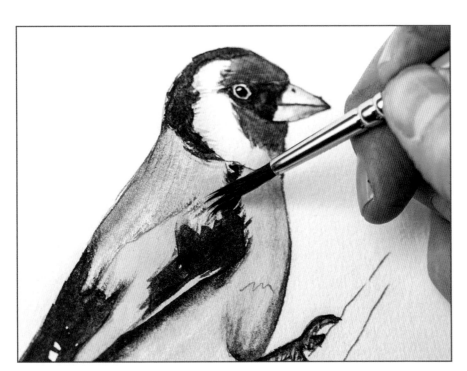

12 Load a size 6 brush with strong grey paint, remove the excess paint and splay the bristles with your fingers. Lightly drag the brush in the direction of the feathers to create a textured effect. Use the dry-brush technique to add further grey to the white area at the back of the head and along the belly, following the contour of the legs.

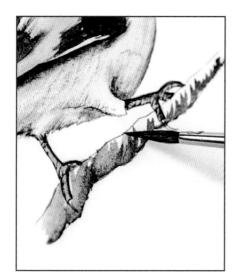 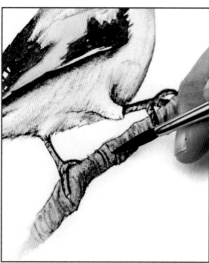 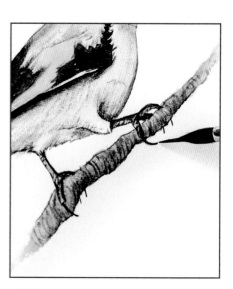

13 To paint the branch, start off with the strong grey and paint a line along the bottom of the branch, creating a slight curve. Quickly move on to add some of the natural yellow that was used on the background of the bird, and blend the paint from the grey upwards.

14 Once dry, pick up more of the strong grey and add a few wrinkles to the branch.

15 Use a size 1 rigger brush and a very heavy grey paint to paint in the tips of the claws.

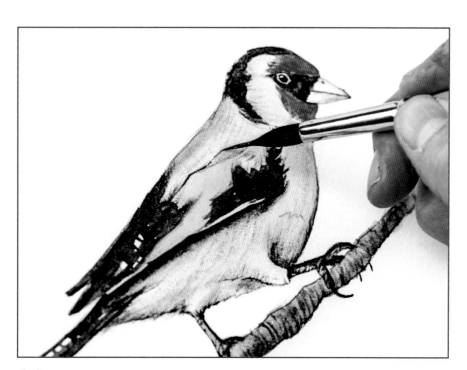

16 Add some final dark lines where a little bit of clarity is needed. I've also added lines to the feathers and legs.

The finished painting.

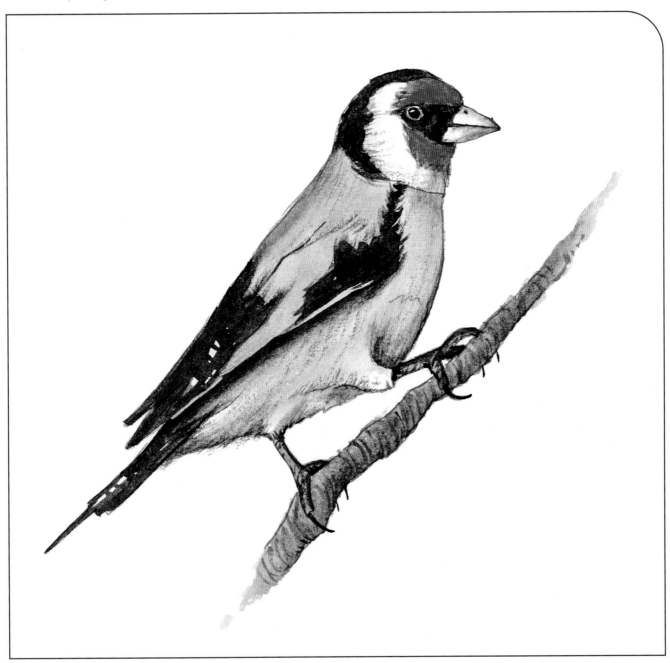

Dolphins

In this project, you will be working with a wet-into-wet background to paint a stunning, vibrant sky. Painting these silhouetted dolphins will teach you how to lift out highlights, paint a sunset sky and create a sense of movement.

When you're ready to begin, transfer the outline to your paper and use a size 20 brush to wet the entire page twice.

Outline 5

You will need:

Brushes: size 6, 10, 20 round, 6mm (¼in) or 12mm (½in) flat

Paint colours:
 natural orange,
 natural violet
 natural grey
 natural yellow light

Other: kitchen paper, craft knife

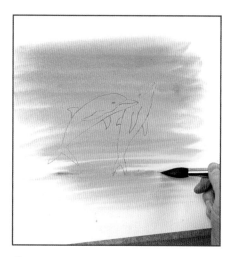

1 Start working on the sky with medium-strength light yellow. Add a few horizontal lines towards the base of the dolphins. Go straight into the medium-strength orange on the upper background.

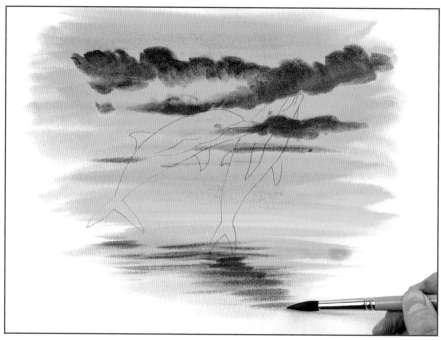

2 Use a size 10 brush with medium natural violet, wiping the brush on the side of your palette. Twist the brush over the paper above the dolphins to add some dark clouds. Allow the violet to mix with the orange. Add a few horizontal lines lower down in the sky, and a few horizontal lines below the dolphins. Keep refreshing your brush in the water and squeezing it through tissue to clean off any paint that is picked up on the brush.

3 Clean your brush again and squeeze it between your fingers to flatten the bristles. Wipe the base of your brush against the damp paper over the clouds. Use the side of the brush and wiping upwards allows you to get the shape to add the highlights to the clouds. Allow to dry.

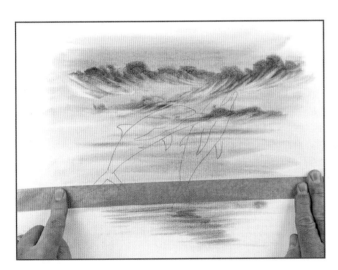

4 Take a strip of masking tape, removing the stickiness by wiping it through your fingers first, and add a horizontal line to the base of the sky.

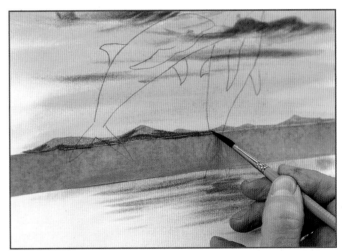

5 Use a size 6 brush with pale natural grey, tapping off the excess colour on kitchen paper to prevent paint seeping down the back of the tape, and paint in some distant hills. Use the masking tape as a straight edge. Add strong natural grey for a darker horizon. This works best while the background paint is still damp.

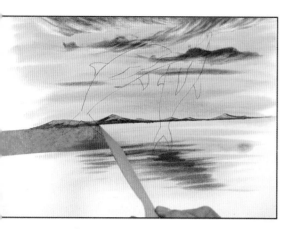

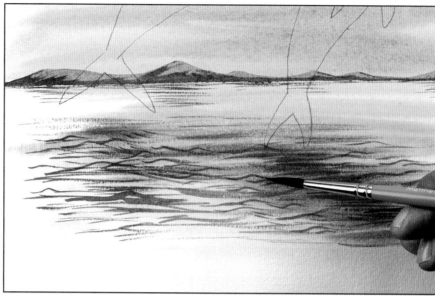

6 Carefully remove the masking tape, pulling it gently at an angle to prevent rips.

7 Add ripples to the foreground with a dry brush, creating some ups and downs to represent the motion of the water – almost like little mountain peaks. The secret is to keep adding more and more ripples over the top of each painted section, all the time tapping off the excess paint on the kitchen paper first to give a textured, dry-brush stroke. The more ripples you add, the more movement the water will have.

Tip

Any bits of seepage behind the masking tape can be hidden by painting a few ripples below the mountains. Use a dry brush and keep the lines horizontal.

8 Using a size 10 brush and an extra strong mix of natural grey, start to paint in the silhouettes of the first dolphin. Be careful not to paint over the mouth of the overlapping dolphin. Leave an unpainted strip along the centre of the dolphin, as shown.

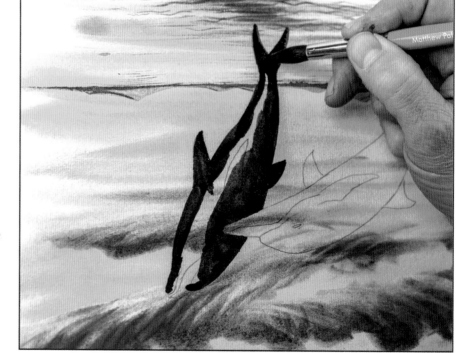

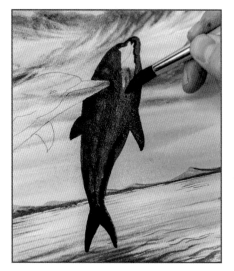

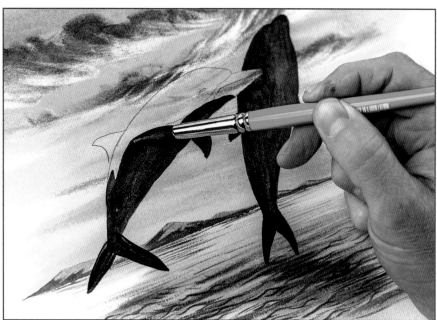

9 When the dark outline of one dolphin is complete, clean your brush and pick up the medium-strength natural violet, wiping away the excess on the side of the palette. Paint in the central area with violet.

10 Paint the left-hand dolphin in strong natural grey, working from the tail upwards, and leaving the top of the head and mouth areas unpainted for now.

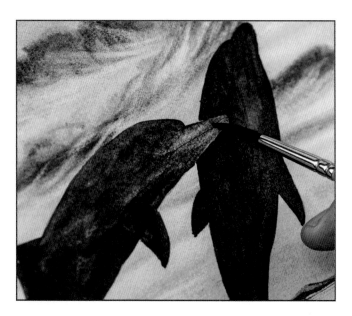

11 Add a line of medium-strength violet across the top of the left-hand dolphin. Paint in the whole area, except where the mouth overlaps the right-hand dolphin. Use a clean, damp size 6 brush to spread the dark colour from the dolphin into the mouth area, smoothing the paint as you go. The mouth area should be lighter than the body. Allow to dry.

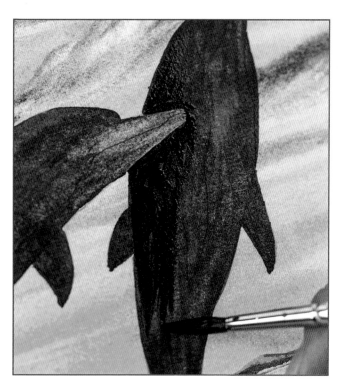

12 Use your size 6 brush to add an extra-dark shadow on the right-hand dolphin where it meets the mouth of the left-hand dolphin. Try to keep a nice clean edge. Continue the dark areas all the way around the mouth area, up along the back of the head and down towards the tail of the right-hand dolphin.

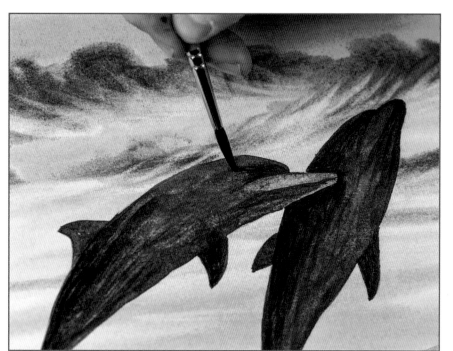

13 Add dark areas to the left-hand dolphin: on the flipper, from the tail upwards along the dolphin's back, and to the top of the head, and below the mouth. Flick your brush away lightly to blend.

14 To give a faint impression of the eye, add a subtle dark spot to the left of the mouth.

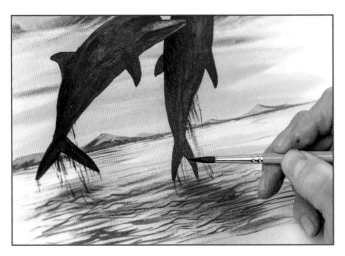

15 Using the same strong natural grey and working with a dry brush, paint in some water drops from the dolphin, working downwards towards the sea.

Tip

It is always advisable to practise first on a separate piece of paper when splattering paint.

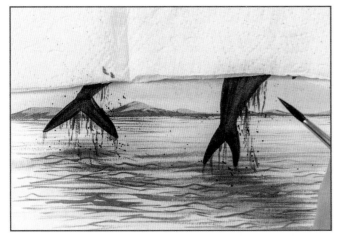

16 Use some kitchen paper to protect the top of the painting, pick up the strong grey paint and flick the brush against your finger to splatter the paint over the lower section of the paper. Turn the brush at different angles to give a random splatter effect.

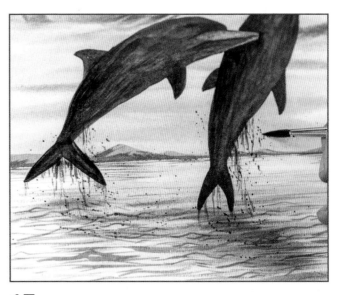

17 Add a few final spots with the tip of a size 6 brush. Allow to dry.

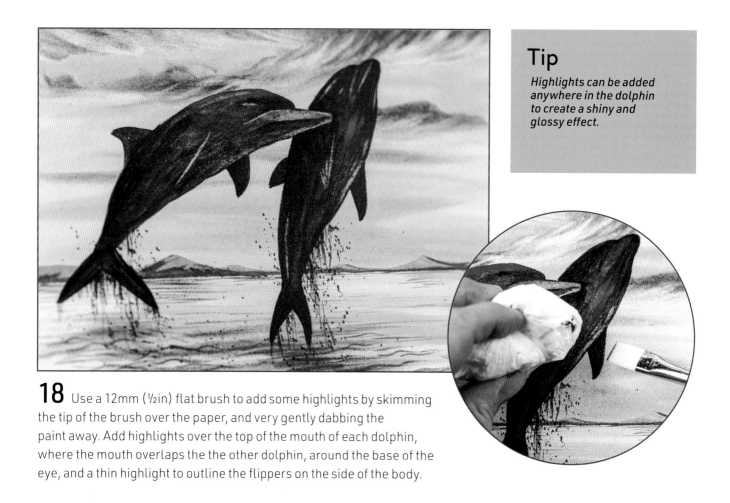

Tip

Highlights can be added anywhere in the dolphin to create a shiny and glossy effect.

18 Use a 12mm (½in) flat brush to add some highlights by skimming the tip of the brush over the paper, and very gently dabbing the paint away. Add highlights over the top of the mouth of each dolphin, where the mouth overlaps the the other dolphin, around the base of the eye, and a thin highlight to outline the flippers on the side of the body.

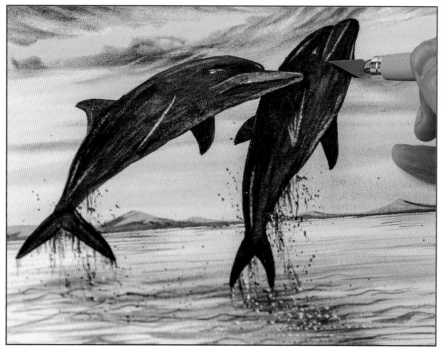

19 Use the tip of a very sharp craft knife to add some final details. Drag the knife downwards and horizontally through the water to create the illusion of movement in the direction you are dragging the knife. Add detail to the eyes with the knife, and a few light edges to the dolphins' bodies, flippers, the edge of the mouth and anywhere that's looking a bit flat. This helps to give a shiny glossy feel to the silhouette.

The finished painting.

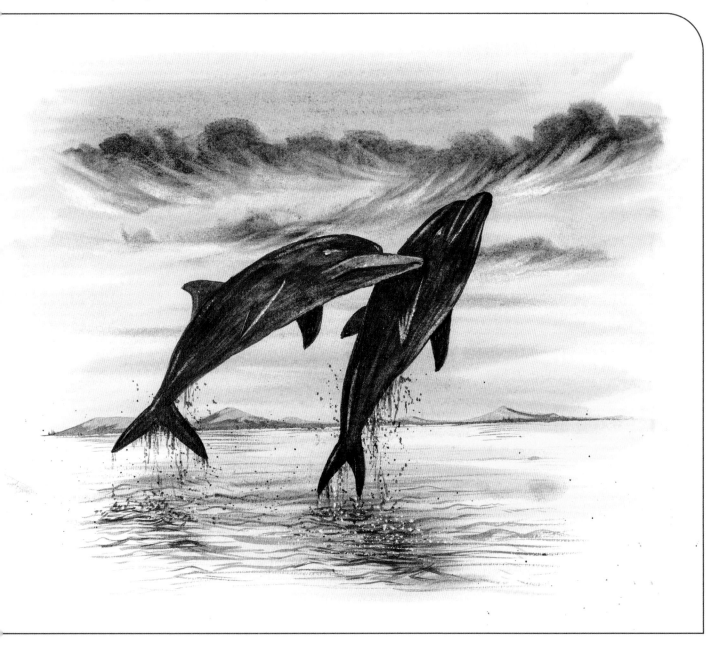

Parrot

The first of the larger projects is this colourful and striking macaw. In this project you will learn how to paint feathers in detail, use strong shadows, paint close-up detail and wet-into-wet backgrounds.

When you're ready to begin, transfer the outline to your paper and use a size 20 brush to wet the entire page twice.

Outline 6

You will need:

Brushes: size 6, 10, 20 round, 6mm (¼in) or 12mm (½in) flat, rigger size 1

Paint colours:
 natural grey
 cadmium red
 natural red
 natural green
 natural green light
 cerulean blue
 natural yellow light
 natural turquoise
 natural yellow

Other: kitchen paper

1 Use natural green light to spot in some background colour on either side of the parrot. Slightly rotate your brush over the paper and allow the paint to spread and bleed into the background. Also add a tiny amount of the green in the middle of the wings.

2 Clean your brush really well and remove excess water by wiping on the side of the water pot. Use natural green, which is a darker green, and again rotate and twist the brush against the paper, allowing the paint to mix with the light green. Loosely avoid painting over the bird.

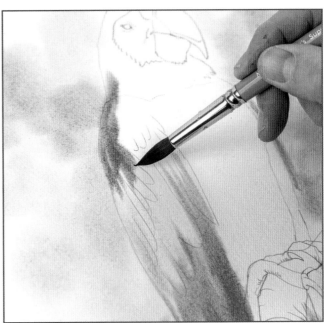

3 Use a size 10 brush and natural yellow light to paint the middle section of the feathers. Then clean your brush and use the medium-strength cerulean blue to paint in the bottom section of the wing and below the perch, and a little strip of blue on the right side of the bird. Use the tip of your brush and lightly drag the blue into the yellow part of the wing, giving a green tinge.

4 With medium-strength cadmium red on a size 10 brush, and removing excess paint on kitchen paper, start to paint in the red parts of the parrot, starting with the top of the wing. Allow the paint to spread and mix with the yellow.

Tip
If the paint isn't mixing too well with the yellow, this can be softened later with a damp brush.

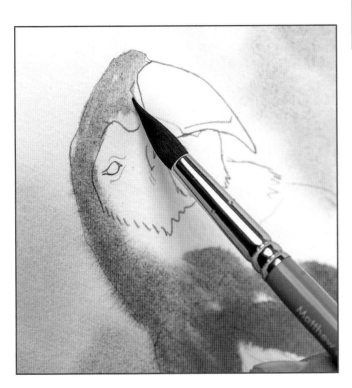

5 Work around the top of the head with the red paint.

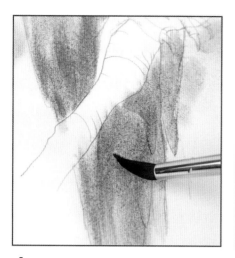

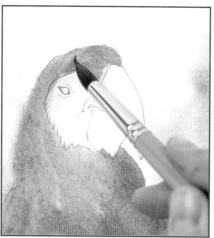

6 As you work on the lower part of the bird over the branch, allow the red to mix with the blue.

7 Pick up the natural red, which is a darker red, again wiping off excess paint from your brush on kitchen paper. Work down the right-hand side of the breast, across the top and right-hand side of the head, allowing the paint to mix with the bright red.

8 To blend in any hard edges of the red, clean your brush, wipe it almost dry, and drag the red down into the yellow to create a more orangey section.

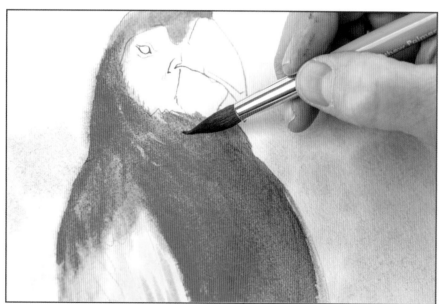

9 Now the paint is starting to dry, return to the medium-strength cadmium red. Starting at the base of the neck, where the head meets the wings, start to sharpen up some of the edges. Follow the shape of the bird, working down the edge of the wing and sharpen up any areas where the paint has bled too much into the background. Revisit the wings at the bottom.

10 Work in the same way for the blue – revisit the wings, especially the edges, and sharpen up where they meet the background, using water to blend in any hard lines. Allow to dry.

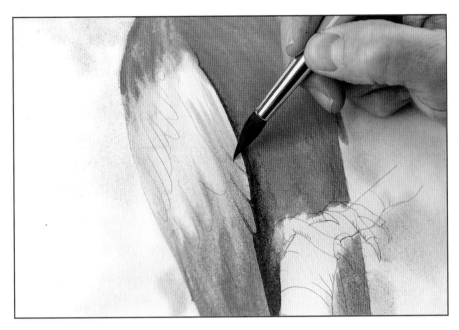

11 Using strong natural grey and a size 10 brush, paint a strong line down the right-hand side of the wing. Gradually taper the line into a thinner point as it gets to the top, making sure it's nice and wide at the base. With a clean damp brush, blend this line across to the right-hand side. It's important to blend the top of this grey line away to nothing towards the top of the bird. Using the point of the brush, carefully drag some grey lines into the wing to represent feathers.

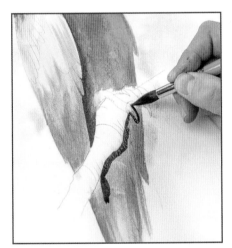

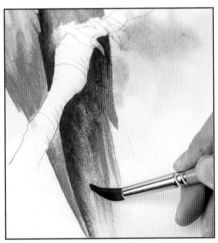

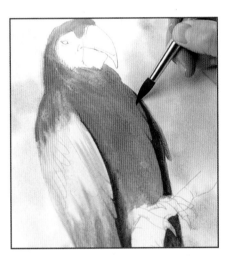

12 Using the same grey, paint in the underneath of the wing below the perch, following the shape of the branch, working all the way across the right side of the bird. Take care not to paint over the claws, and then blend the line downards.

13 Clean your brush, remove excess water and blend the grey line smoothly towards the bottom of the tail feathers.

14 Continue the dark shadow from the top of the claw up along the breast of the bird. Blend this across to the right with a clean, damp brush.

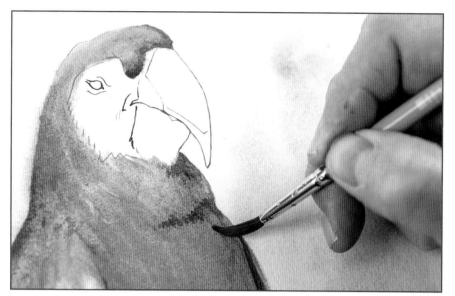

15 Using the same strong natural grey, paint a shadow across the end of the red feathers on the top of the head – this needs to be quite a clean edge. Add a grey shadow to the top of the wing, and directly underneath the bottom of the beak, working slightly down the right-hand side of the neck. Add a feathery line underneath the collar, carefully blending away these areas, working up and down if needed.

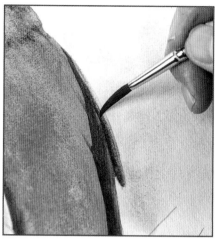

16 Add another shadow to the wing on the right side of the painting to separate the individual feathers. Blend this away with a damp brush.

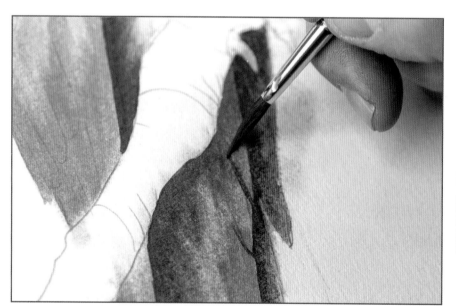

17 Using the same strong grey, work underneath the perch and carefully paint around the overlapping claw, separating the wing from the bottom part of the bird. With a clean damp brush, drag your brush to the right to blend out those feathery lines.

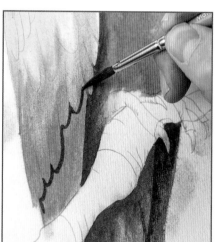

18 Using the same grey, start at the bottom of the wing and begin to lay the shadows underneath the feathers following the curved tip of the area, and working in sections.

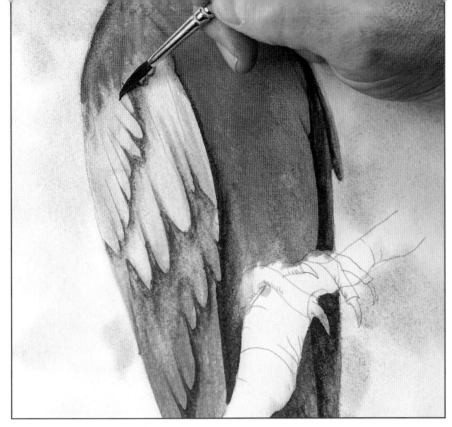

19 Use a clean size 6 brush, removing the excess on kitchen paper, blend this hard line down into the wing. Use the tip of the brush in between each feather to add a natural-looking shadow between each feather. Continue to work over the whole wing using the same technique.

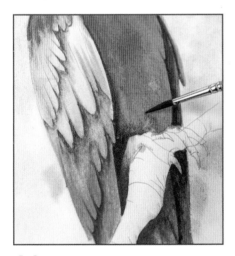

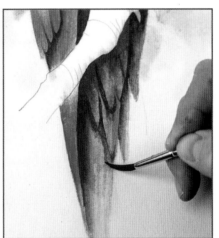

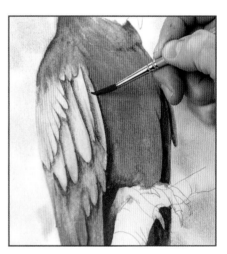

20 Using the same brush and strong grey, follow the line that sits above the feet, then follow the profile of the wing and work towards the centre of the bird's belly.

21 Working on the tail feathers below the perch, add a few shadows underneath the feathers – only a few shadows are needed and they look almost like a lower-case 'l' shape. With a clean brush, removing excess water, blend these shadows away at the top and down towards the bottom of the picture.

22 Using the same grey with the same brush, come back to the wing and add a few shadows to separate a few individual feathers. These new shadows will go all the way underneath the previous shadows, and, with a damp brush, can be blended off to the right. Take care to remove any excess water on your brush before blending.

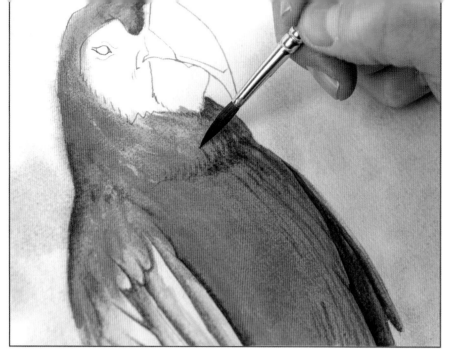

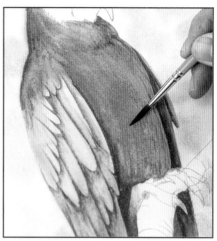

23 Load a size 6 brush with a medium-strength natural grey (about 50% water, 50% paint) and remove the excess on the tissue so you have a slightly drier brush. Start to add some quick feathering movements following the contour of the belly and the breast of the parrot. These are best painted with quick, dry brush strokes. Follow the curves of the breast coming down towards the belly, and then change direction as you work up into the collar.

24 Blend any hard lines with a damp brush by working these areas away from the shadow that's underneath the wing. Also add some of these contour lines at the back of the neck towards the top of the head.

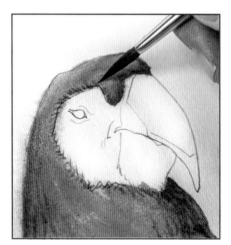

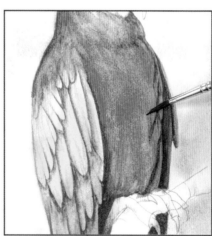

26 Using the same medium natural grey on a size 6 brush, add a few shadows to the base of the belly, just above the claws, almost working in a 'l' shape – with the darker part of the line at the top of the claws, and tapering the line so it disappears towards the wing. Add a couple more of these lines higher up, on the right-hand side of the painting. With a clean damp brush, blend these away to the right.

25 Add a few of these lines to the wings and feathers; again these are best painted with quick, dry, brush strokes. Add tiny grey flecks around the area where the red feather meets the white part of the bird's head.

27 Using the same medium grey, wipe your brush on kitchen paper and splay the bristles between your fingertips. This is a great way of adding fine detail to some of the larger feathers. Paint in fine diagonal lines down the right side of the feathers, and then on the opposite side, which may work better if you rotate the board. Repeat this on each feather. Then, use the spikes of the splayed brush and gently tap down the centre of the larger feathers to create the central spine of each individual feather.

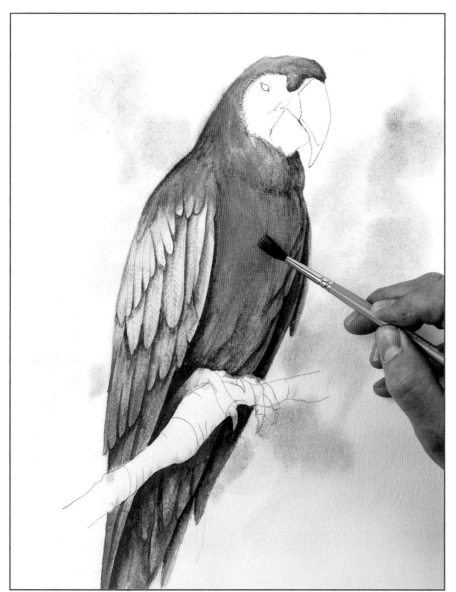

29 Use the same dry-brush technique around the white part of the face, working outwards from the beak and being careful to follow the shape of the eye. Add these very fine, dry lines.

Tip

Practising these fine, dry-brush lines is essential. Why not try them out on a spare piece of paper first?

28 The same spiky dry brush can be used to add a very fine texture to all areas of the parrot, following the contours of the bird. This is a great way to fill in any areas that have less texture.

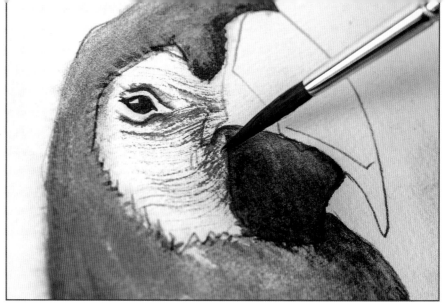

30 Using strong natural grey, paint in the eye, leaving a thin white highlight inside the eye. Add a thin line of the same grey above and below the eye to give the impression of the eyelid. With a clean damp brush, removing the excess water on tissue, blend the line into the parrot's face.

31 Use strong grey to paint the beak. Start off by blocking in the bottom section – once this is around two-thirds painted in, use a clean, damp brush to blend upwards so the grey fills the bottom section of the beak. Use the tip of your brush to gently feather the edges so this dark section of beak blends smoothly where it meets the white flesh and the red feathers at the bottom.

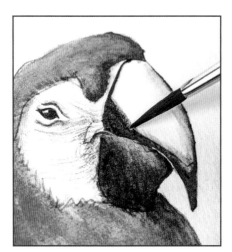

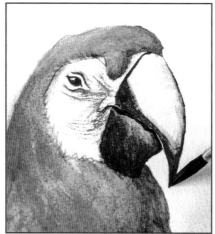

33 Add some pale natural yellow curved lines all the way down the beak. Using some of the red paint that was used for the feathers of the bird, and a dry size 6 brush with spiked bristles, lightly add a few red areas over the white part of the face. To paint the opening of the beak, use strong grey and add a line just below the top section of beak – this line can be quite random. Add a touch of extra darkness to the pointy tip of the beak.

32 Outline the upper section of the beak with a strong grey line, carefully filling in the corners as shown. Slightly feather the edge of the dark grey triangular section of the top part of the beak.

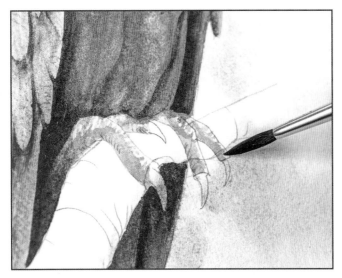

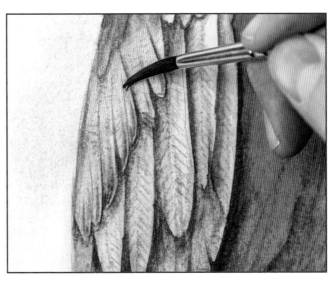

34 Using a mix of pale natural grey with some natural turquoise or viridian hue on a size 6 brush, paint the lower two-thirds of each toe in a series of random wrinkly lines. More wrinkly lines can be added over the top of the entire toe area once dry to give added texture.

35 Also add the natural turquoise or viridian hue to create a tiny tip on the end of the yellow feathers – use water to soften these if needed.

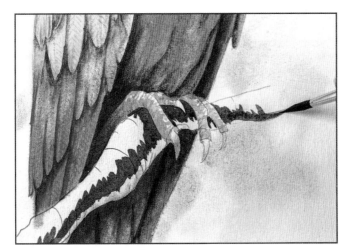

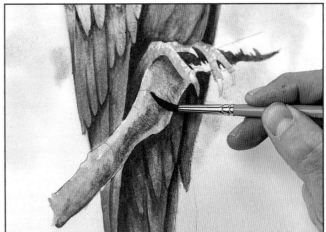

36 Using a medium to strong natural grey (60% paint, 40% water) on a size 6 brush, paint a shadow on the bottom of the branch, being careful to leave a gap where it overlaps the dark sections of the bird. Work neatly around the edge of the bird's claws.

37 Using natural yellow, fill in the rest of the branch – you can almost scribble in the paint to give added texture. Make sure the darker areas blend well with the added yellow. Allow to dry.

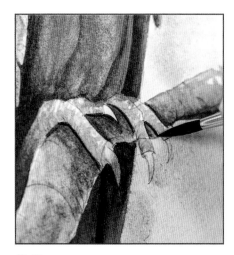

Tip
Consider using a finer brush if you struggle to use a size 6 for the finer details.

38 Use the same size 6 brush with a strong natural grey, working again with a dry brush. Add little shadows just underneath the toes where they sit on the branch.

39 Add some directional lines to the branch at this point, following the curve and adding more wrinkles. Add further very fine lines in dark grey to intensify the contrast of the branch, and also add some shadows underneath the branch.

41 Use a damp brush to gently soften the wrinkles on the toes.

40 Use the same strong grey with a dry brush and lightly drag some lines over the base of the feet, and add some dark wrinkles where the claw meets the branch.

42 Use strong grey to paint in the two claws that overlap the green background. For the claw that overlaps the dark part of the parrot, paint in a dark line down the centre of the claw. Blend in using a damp brush.

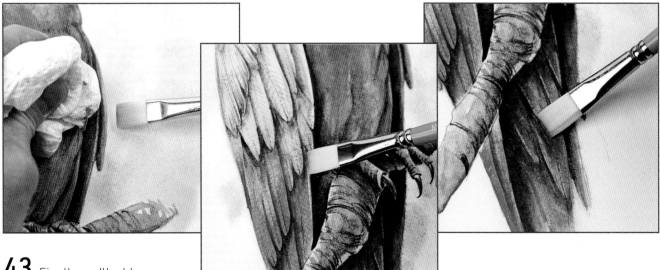

43 Finally, we'll add some highlights to complete the parrot.
Take a clean 6mm (¼in) or 12mm (½in) flat brush and gently remove any excess water from the brush. Use this brush on any areas that you feel need a bit of light – I've added highlights down the right side of the breast, where the wings meet and where feathers overlap.

Tips

Adding highlights has a huge impact on the tip of the wings and feathers under the branch. It's worth spending time with this lift-out brush as it really gives a three-dimensional effect to the feathers.

The trick to adding highlights is to lightly scrub the brush against the paper and then tap away the excess paint with tissue/kitchen paper (see pages 36–37 for more on lifting out).

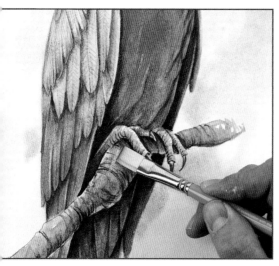
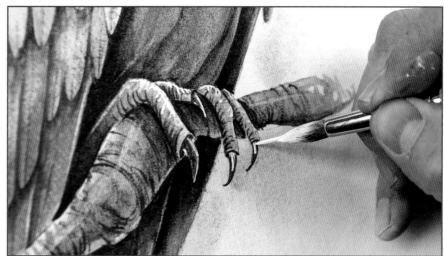

44 Add a highlight across the top of the toes to make them look more three-dimensional, and one along the centre of the branch to give a shiny/reflective feel to the wood.

45 Use a size 1 rigger or a branch and detail brush with some opaque white and a tiny bit of water to add some more highlights to the bird. These work well across the top of the claws. Add some paler wrinkles to the top of the toes, working down towards those dark wrinkles below.

46 Paint a few white highlights on the top section of the beak to add shine, and add a few white lines where the two dark parts of the beak meet. Where the white section of the head meets the red feathers, add some white flecks of paint – this helps to blend the white in with the red. And finally, add a few white lines around the wings, the feathers and on the breast to create a three-dimensional effect.

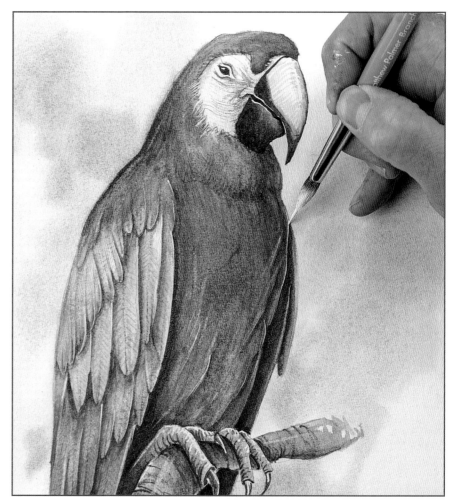

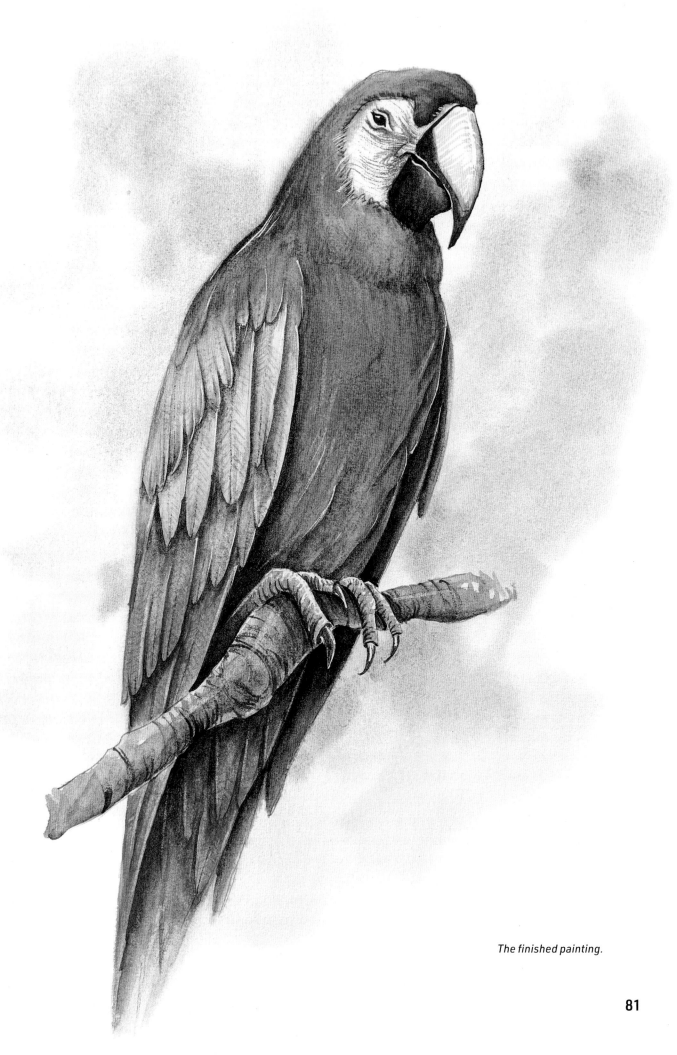

The finished painting.

Cheetah

This charismatic cheetah is a good example of my favourite style of animal painting – I love painting animal portraits. Featuring wonderful detail and a fur technique, in this project you will learn how to paint beautiful cats' eyes, mouth details, whiskers and fur.

When you're ready to begin, transfer the outline to your paper and use a size 20 brush to wet the entire page twice.

Outline 7

You will need:

Brushes: size 6, 10, 20 round, 6mm or 12mm flat, size 1 rigger

Paint colours:
natural green light
natural brown
natural yellow
natural grey
natural red
opaque white or white gouache

Paint mix:
warm brown, mixed from natural yellow (50%) and natural brown (50%)

Other: kitchen paper

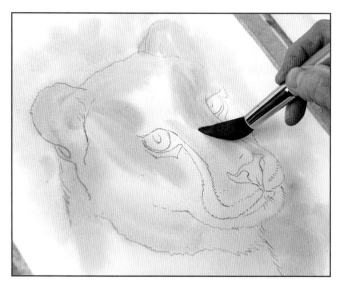

1 Paint a simple background as described in the techniques (see pages 24–25), using pale natural green light and pale natural brown. Work wet-into-wet to give a lovely out-of-focus feel. Clean your brush really well, then start to paint in the cheetah's face using medium natural yellow, following the shape of the head. Keep picking up more colour and keep your brush moving.

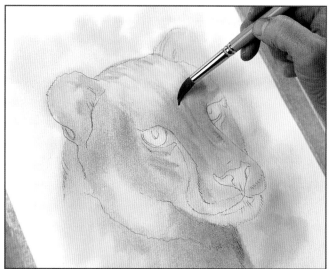

2 Working in bold brush strokes that allow the paint to disappear into the background, pick up the warm brown mix on a size 10 brush. Working wet-into-wet, add some brush strokes down the centre of the nose and across the top of each eye, then continue to follow the shape of the animal, picking out the darker areas: around the eye, inside the ears, underneath the jaw and across the top of the head. Allow to dry.

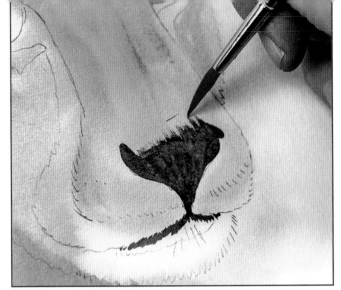

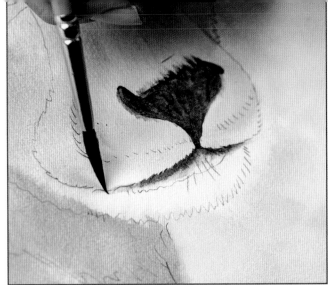

3 Use a size 6 brush to block in the nose and mouth with strong natural grey – use a series of little diagonal brush strokes for the mouth. Clean your brush really well, then gently feather the paint upwards.

4 Keep refreshing your brush in the water, and blend in the same way on the left and right side of the nose, coming out from the nostrils. Blend the darkness inside the mouth downwards slightly, using the same technique. This line should gradually disappear as it follows the shape of the mouth on the left and right side.

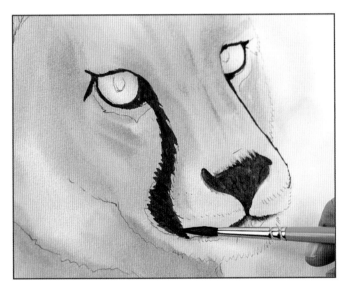

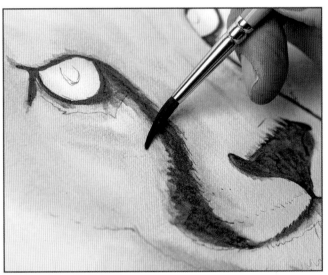

5 Paint in the darkness around the right-hand eye. Don't paint the whole way around the right-hand eye, as shown above. Continue the line from the eye downwards towards the nose. Don't be afraid of using strong colour here – it's very easy to blend even after the paint is dry, and these lines will be softened in at a later stage. Wash your brush well, wipe it almost dry on kitchen paper and then go back to the right-hand side of the picture and just gently feather away the darkness, working away from the eye.

6 Keep working with the size 6 brush and feather away these dark lines, all the way down the side of the face from the eye to the mouth.

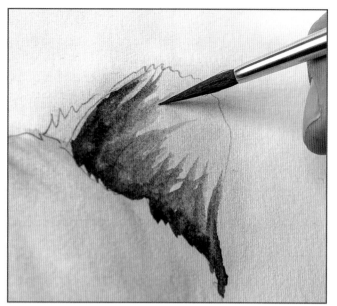

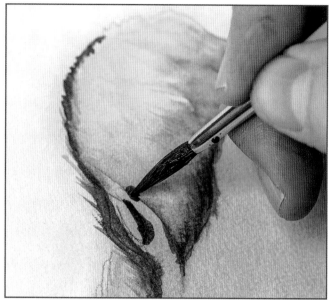

7 Using the same strong natural grey on a size 6 brush, add some shadows in each ear. To blend, use a pale warm brown mix – which was used in the background – and paint quite freely inside the ears, to suggest long hairs.

8 Using the same grey and same brush, add a dark shadow along the edge of the ear, working down the left-hand side. With a clean damp brush, lightly feather the dark paint into the ear and down into the head. A few tall hairs can be added by flicking the damp brush out from the grey area into the background. Paint a dark grey spot on the left ear. Once painted in, clean your brush, wipe it dry, and gently feather this spot into the rest of the ear. Repeat this effect on the opposite ear.

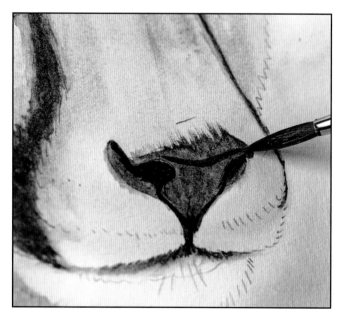

9 Using extra-strong grey, add a very dark shadow inside both nostrils. Continue the line down towards the mouth, almost in a funnel shape with a line across the top of the nose. Clean the brush, wiping it almost dry, and gently feather that shadow from the bridge of the nose down towards the base of the nose. Don't worry if a bit of paint is lifted off or removed in this process.

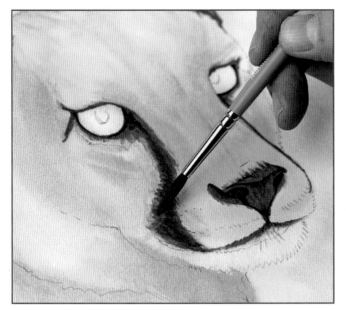

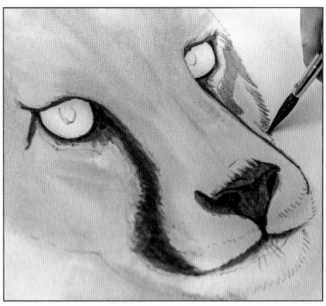

10 Using the very dark grey and a size 6 brush, paint a very fine dark line around the eyes, including the corners. The line running down the nose and mouth can be made a little bit darker at this stage with the same colour – all with a dry-brush technique.

11 Using a pale warm brown mix, paint a few dark areas on the cheetah, starting just below each eye.

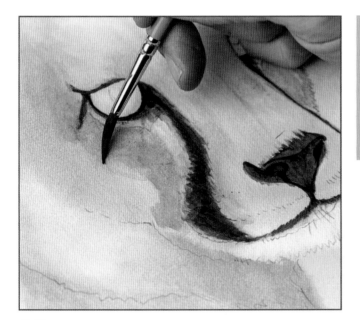

Tip
To create a dry brush, pick up the paint and gently remove the excess on some kitchen paper and try to paint with the side of the brush rather than the tip.

12 Repeat this effect on the left-hand side, leaving a lighter area just below the eye. Lightly feather darker patches on both sides to blend them into the face.

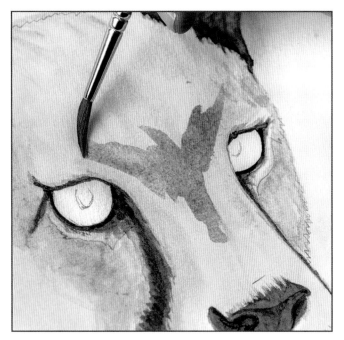

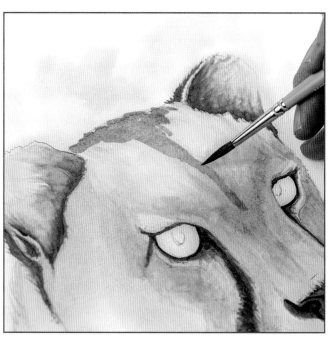

13 Add another patch of this darker colour down the centre of the nose, like a funnel shape between the eyes. Use a clean damp brush to blend this funnel shape before it dries.

14 Add another tan patch at the top of the head, almost like a letter 'T' shape.

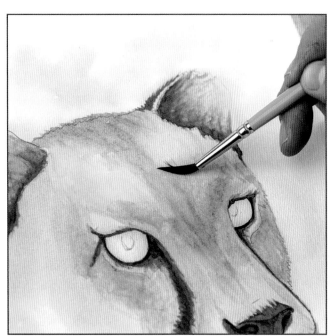

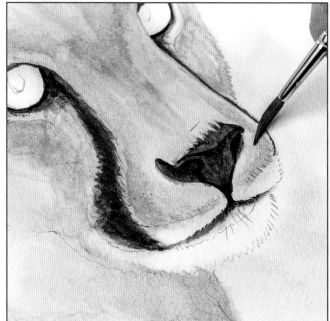

15 Blend this using the side of your brush.

16 Add an area of this tan colour to either side of the nose, working towards the mouth. Blend these lines inwards towards the nose.

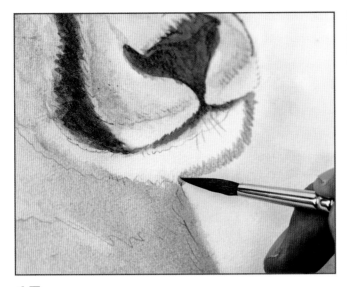

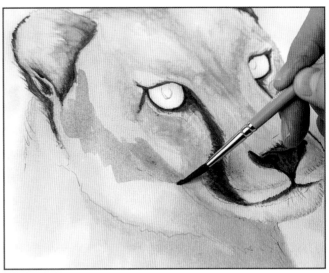

17 Using a tiny bit of the tan colour, add some furry hairs around the mouth until it meets the rest of the body. Use a clean brush, wiped on tissue, to blend this up to the mouth.

18 On the left-hand side of the painting, add some of the tan colour coming from the base of the ear working down towards the mouth. Again, a clean brush wiped on tissue allows this to be blended into the fur.

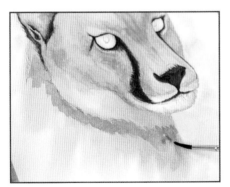

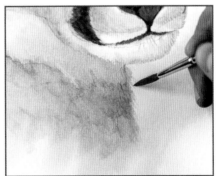

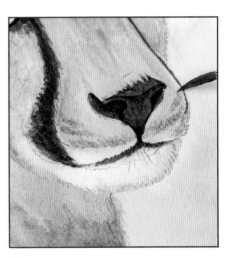

19 Add a shadow, almost like a collar effect, using the same tan colour on the same brush. Make sure the lines are slightly diagonal to give a random fur effect, and use water to blend this downwards. Blend in this 'collar' effect to make it look a little bit more furry.

20 Add a few individual hairs to the right-hand side of the neck, using the same colour.

21 Add in some individual markings around the mouth, and paint some little diagonal lines almost like a moustache. With a clean, dry brush, gently feather away these areas.

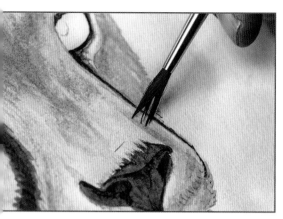

22 Add a tiny spot of natural red into the colour to create a pink tone. Use this with a dry-brush technique – picking up the paint, dabbing off the excess on kitchen paper and splaying the bristles – for adding some texture to the fur.

Add some individual hairs inside the ears, filling in some of the blank areas.

Add dry-brush strokes down the centre of the nose, working up around the eyes and up towards the top of the head.

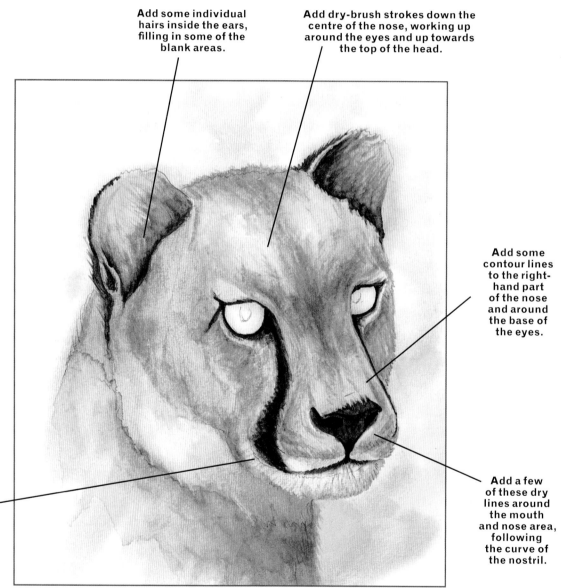

Add some contour lines to the right-hand part of the nose and around the base of the eyes.

Drag your dry brush down into the bottom section of the mouth, almost creating individual hairs.

Add a few of these dry lines around the mouth and nose area, following the curve of the nostril.

23 Use the dry-brush technique to add details to the cheetah as shown. This technique can be used anywhere to give extra detail and add more texture, all the time using a splayed brush, using the brush vertically rather than horizontally.

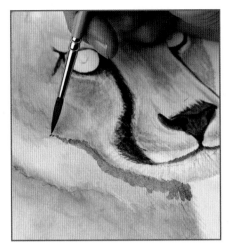

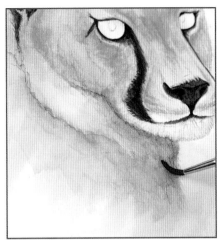

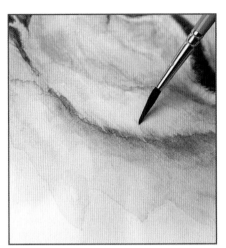

24 Use a size 6 brush and a pale warm brown mix, with the colour being more towards the grey. Start off by adding quite a confident shadow underneath the chin, made up of little diagonal lines. Taper off this shadow area to a thin diagonal line, as shown above.

25 Work fairly quickly with a damp brush, then add a shadow down towards the bottom of the picture, with the occasional upwards flick to represent the random furry edge.

26 Add more shadows just below the collar, again painted with little diagonal brush strokes. With a clean damp brush, blend this in the same way as the previous shadow, with a few upwards strokes in a random fashion.

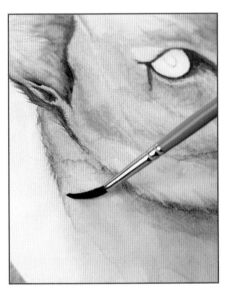

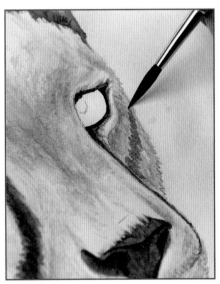

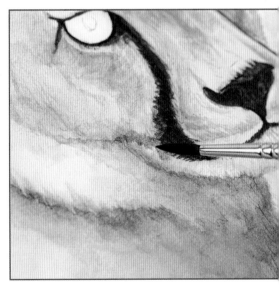

27 Paint a slightly darker edge coming down the back of the cheetah with a slightly diagonal flick to make it look more furry. This can be blended in the same way as the previous shadows.

28 Add another area of shadow to the right-hand side of the painting on the cheek area below the eye. Blend in the same way as previously.

29 Add a slight shadow just to the left of the black stripe that runs down the edge of the mouth. Blend this in.

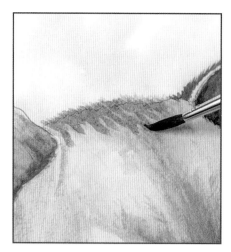

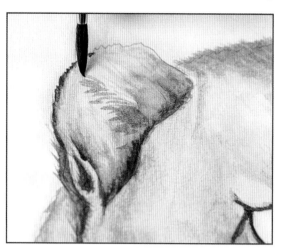

30 Add in some darker lines across the top of the head with diagonal brush strokes, then blend these lines down into the head.

31 Add some diagonal lines inside the ear to give some extra depth. With a clean brush and the tip of the brush, lightly blend these away from the animal. Repeat on the opposite ear.

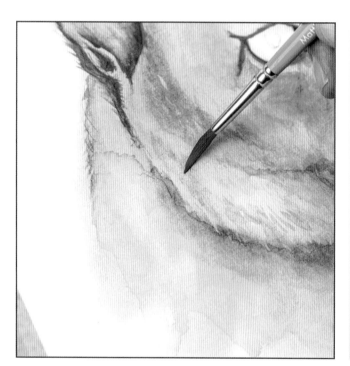

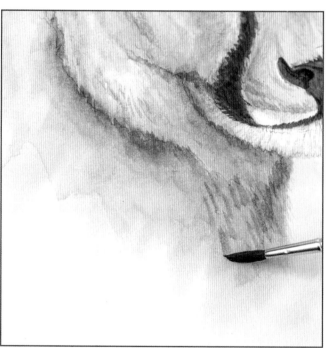

32 Add a few diagonal shadow lines down the left side of the head, working down towards the cheek. A clean brush allows this to be blended in smoothly. Add some more of these diagonal lines just below the jaw, working towards the collar. Blend in these lines. Lightly skimming the brush over the top is enough to soften these shadow lines.

33 Add a few more diagonal lines underneath the mouth and jaw, working down into the body, again, blending in as you go.

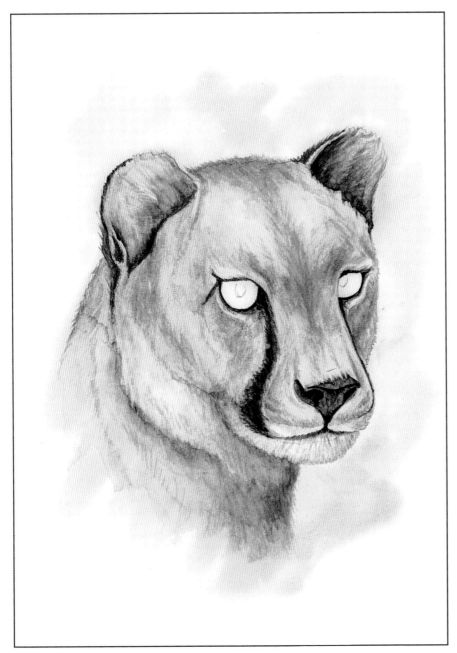

34 At this stage, take a look at your painting and fill in any flat-looking or blank areas with more of these diagonal lines, using the warm brown mix mix. Add lots of random directional flicks around the head, following the shape of the animal. Start on the head by creating a sort of centre parting in the fur, which goes to the centre of the nose, then work around the eye, and anywhere that still looks a little bit empty. Add a few of these dark grey flicks around the mouth and nose, and on the edge of each ear to make them stand out more against the background. Hundreds of random little flicks with this colour will really give the impression of thick fur.

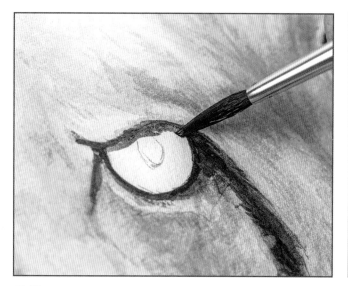

35 Use a strong natural grey to paint in the left-hand eye – paint a strong line across the top of the eye.

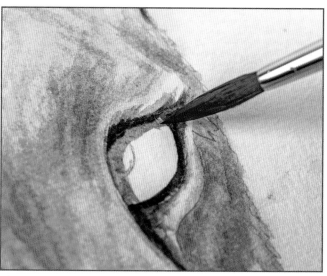

36 On the other eye, add a grey line across the top, starting from the edge of the nose.

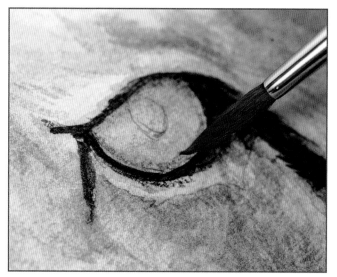

37 While the grey shadows are still wet, use pale natural orange on a clean brush to block in each eye. While the orange is damp, use the natural grey and just lightly tap the brush along the bottom edge of the eyes, working all the way around the base.

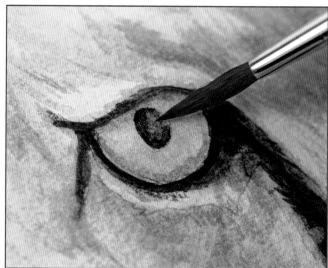

38 Using natural grey and a small pointy size 6 brush, paint in the two pupils – these are oval shape on big cats and are painted almost like a letter 'C'. Fill in more on the left-hand side of each pupil. Use a clean damp brush to complete the circular shape of the pupil, creating a lighter side – this gives depth to the eye. Using the tip of the brush, dab in the outline very gently to create a softer shape as opposed to a hard edge. Leave to dry.

39 Working with a very strong grey (90% paint, 10% water), dry your brush on kitchen paper, splay the bristles and begin to add spots to the fur. Using the side of the brush will utilize the textured grain of the watercolour paper.

Tip

Not all spots are large and round. The spot on the face is more like a stripe down the centre of the forehead. It's helpful to have a reference photograph to use here for the smaller details.

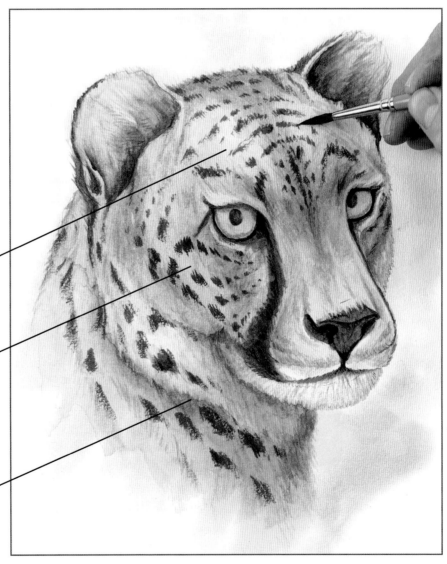

Note the pattern of the spots on the forehead – the markings follow a curved shape, almost like a furrowed brow line.

Notice how the spots follow a curved formation over the cheek and underneath the eye.

The spots become larger and more randomly spaced as you work lower down the neck.

40 Continue to add spots over the head and around the neck. Use the side of a brush to create a large area of a spot here and there. The trick is to gradually taper away as you work lower down on your animal, creating a vignette-style painting.

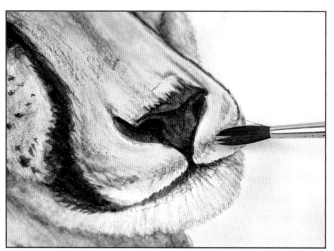

41 To add overall texture to the cheetah, pick up some medium-strength natural grey on the brush, wipe it off on kitchen paper and splay the bristles. Use the tip of the bristles to add random texture over any areas on the animal – this will create the fur-like texture. Areas to pay particular attention to with this technique are around the nose, inside the ears and around the mouth area where the whiskers will be added.

Tip

It's well worth practising this dry-brush technique first to make sure you're not putting too much paint on the brush or too much paint on paper.

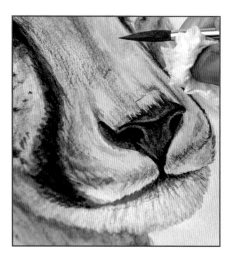

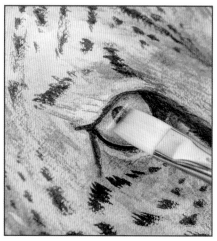

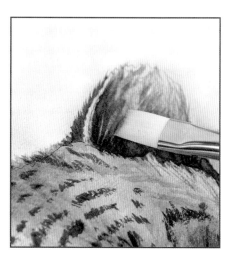

42 Add some highlights, starting with the nose, by using a damp size 6 brush. Add water to the nose just above the nostril and firmly tap with kitchen paper to remove the paint. Add more highlights at the bottom of the nose area, working downwards towards the mouth, and across the top towards the bridge of the nose.

43 Use a 12mm (½in) flat brush to add a horizontal highlight on the top of each eye. This gives a marble-like glaze to the eyes. Also add a few highlights above the eyes, to give the impression of some tall, lighter hairs.

44 Add highlights in the same way inside the ears.

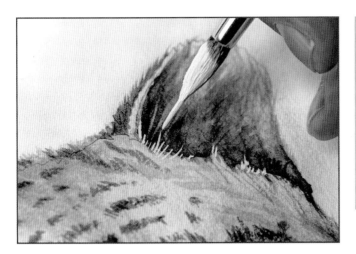

95

Tip

When using opaque white, it is best used fresh from a tube and squeezed out onto a clean piece of paper, otherwise it can contaminate your palette. It's a good idea to use a tiny amount of water when using white paint – too much water and the paint disappears when it dries.

45 Using a size 1 rigger or branch and detail brush with white opaque paint, add some fine hairs inside the ears.

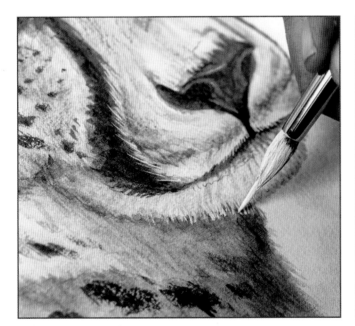

46 Add some fine white hairs along the top of the dark edge for the mouth – it's a great way to make it look more furry/hairy – working on the left-hand side of the mouth overlapping the dark stripe. Paint some longer white hairs on the bottom of the chin, overlapping the background.

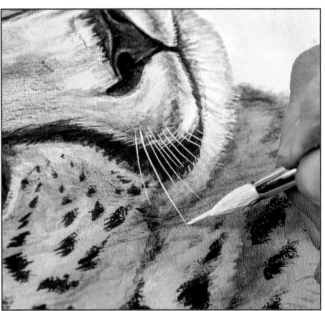

47 Add some whiskers on the left-hand side of the painting. Whiskers are best painted in the direction they grow, painted in one long brush sweep with white paint. Rotating the board can make this process easier.

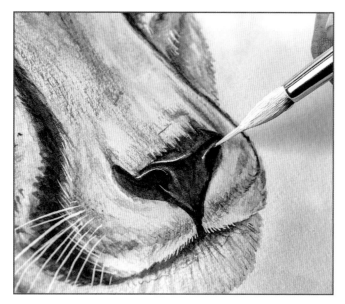

48 Add a few further white highlights to the nose to give the appearance of it being slightly shiny or wet; these work best along the edge of the nostril.

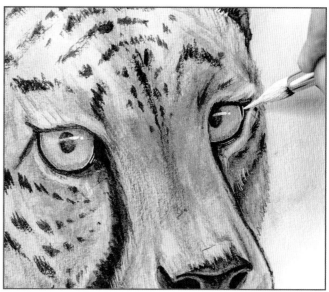

49 Add white highlights to the eye – one longer line and one spot to the side, then add a few white highlights around the edge of the eye where it meets the dark flesh. Add this to both eyes to really add extra life to the animal.

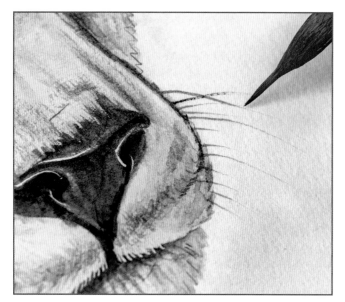

50 As the whiskers on the right-hand side are overlapping the background, they can be painted with a size 1 rigger or branch and detail brush, using some of the grey paint left in your palette. Work outwards from the face, trying to paint each whisker with a single stroke of your brush.

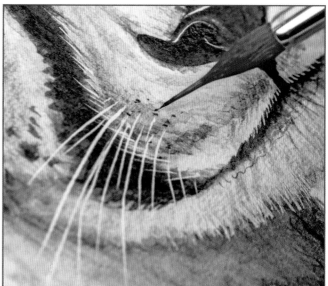

51 Finally, add a few grey spots around the base of the whiskers on both sides.

Opposite: The finished painting.

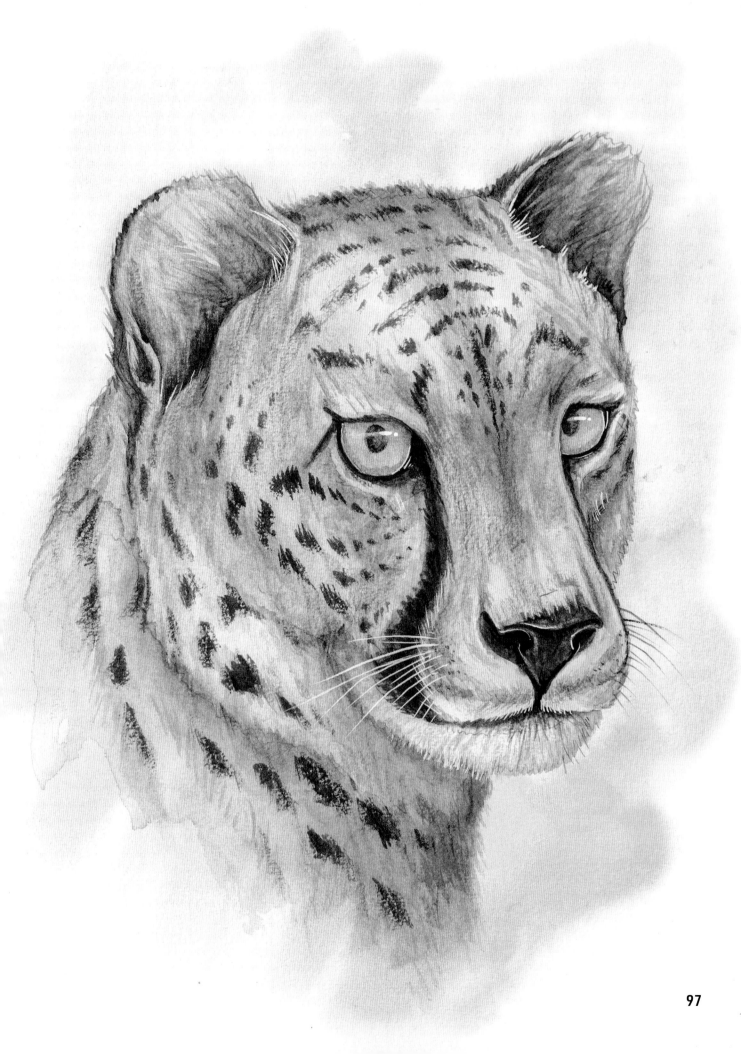

Sea turtle

With an underwater background using plastic food wrap, this painting of an elegant sea turtle makes for a very pleasing watercolour painting. In this project you will learn how to create a dappled light effect, work with shadows and add shell markings.

When you're ready to begin, transfer the outline to your paper and use a size 20 brush to wet the entire page twice.

Outline 8

You will need:

Brushes: size 6, 10, 20 round, 6mm (¼in) or 12mm (½in) flat, rigger size 1

Paint colours:
 natural grey
 natural green light
 natural brown
 natural yellow
 natural turquoise
 natural orange
 natural blue
 natural red
 opaque white or white gouache

Paint mix:
 grey-yellow, mixed from medium-strength natural grey with a touch of natural yellow

 brown-grey, mixed from natural grey (80%) with natural brown (20%)

Other: kitchen paper, plastic food wrap

1 Using natural turquoise, hold the brush flat to the page and rotate it over the paper to create a swirly effect. Don't worry if the paint goes over the outline of the sketch. Lay the board totally flat to allow the paint to run in different directions.

2 Clean your brush really well and pick up natural blue, randomly twisting the brush on the page over the turquoise. Clean the brush again and this time add a few spots of natural red towards the bottom of the page, using a stippling or tapping action. Add a few spots of strong natural grey in the foreground.

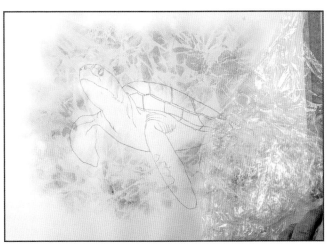

3 Work quickly while the background paint is still wet. Take a piece of plastic food wrap around the size of your painting, lay it flat, covering the entire paint area, and wrinkle it with your hands over the paint. Leave until the paint has almost dried. It's best to leave it to dry naturally.

4 After about 5–6 minutes, carefully peel off the plastic food wrap and allow the paint to dry fully.

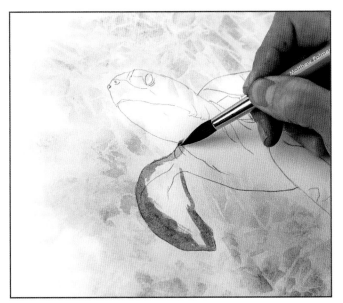

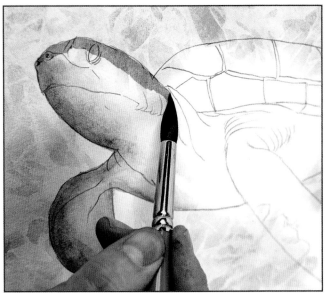

5 With medium-strength grey and a size 10 brush, paint a thick outline around the flipper, along to the nostrils.

6 Outline the head with the same grey and, every so often, change over to natural yellow, and blend this out from the grey, allowing the grey paint to blend with the yellow on the page. To prevent hard lines, work on small sections at a time. Blend in each section with a clean, damp brush, fading the lines towards the centre of the turtle.

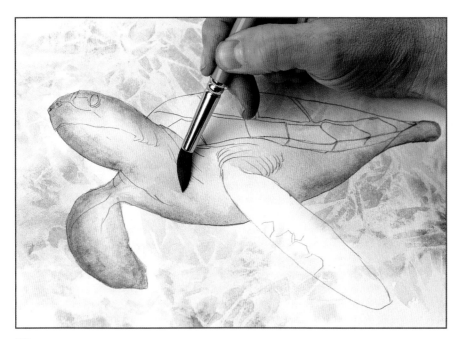

7 Continue to paint around the edges of the turtle with the grey, using natural yellow to blend the grey towards the centre of the head and down into the body.

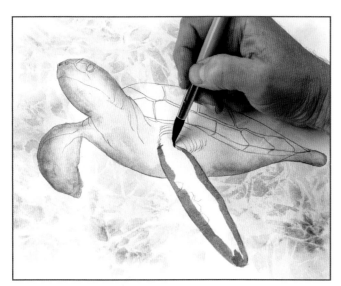

8 Use the grey-yellow mix and paint the large flipper in the same way. Paint a grey outline first, blend in with natural yellow, and then finally blend in with water.

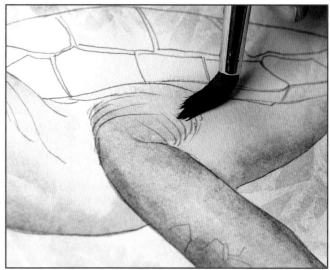

9 Blend the flipper with a damp brush, sweeping into the muscular part of the body where it connects just below the shell. Allow to dry.

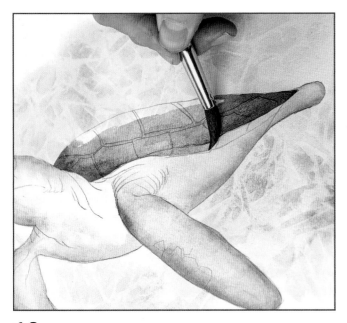

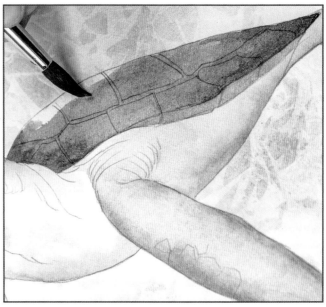

10 Use strong natural grey with a size 10 brush to paint a dark shadow on either end of the shell, following its shape. Clean your brush, use the pale natural brown and blend away from the grey on both sides.

11 Introduce a few patches of pale natural yellow on the top of the shell. Add a few spots of natural orange to give a slight variation in colour.

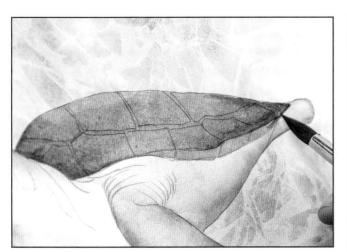

12 While the natural orange is on your brush, revisit the entire shell, working right to the edge where the grey paint is, blending everything together.

13 While the entire shell area is still wet, place a fresh piece of plastic food wrap over the shell – the plastic wrap will only stick to wet paint. Leave to dry for 5–6 minutes before removing the plastic.

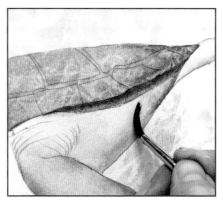

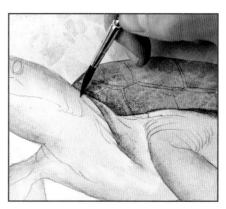

14 Using strong natural grey and a size 6 brush, begin to add shadows to the turtle. Start with a grey line, following the contour of the shell and working all the way towards the tail.

15 With a clean damp brush, blend the grey shadow downwards into the body.

16 With the same grey, add a line representing the 'crease' at the base of the turtle's neck; this curves down towards the flipper. With the same damp brush, drag a few lighter grey lines up towards the head.

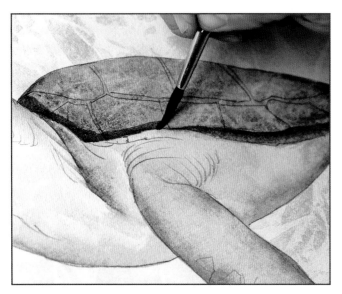

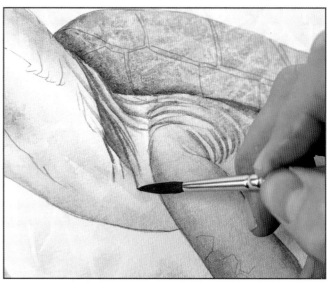

17 Add a dark shadow on the left side of the shell, and blend this upwards with a damp brush.

18 Using the point of the size 6 brush, add some wavy lines curving around the flipper. Add several of these, then clean your brush and lightly feather the lines to make them look more natural, making sure that the ends of these folds are completely blended away.

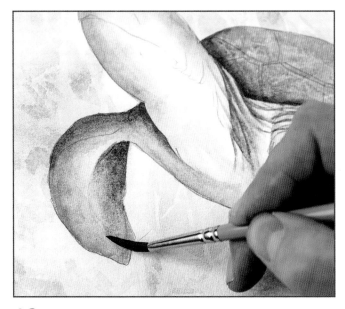

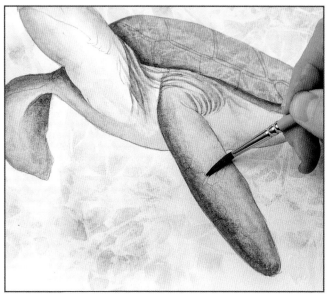

19 Paint a strong grey shadow along both sides of the left-hand flipper, and blend these lines downwards, towards the opposite flipper.

20 Use the same strong grey all the way down the left edge of the large flipper, slightly overlapping the creases added in step 18. With a clean, damp brush, blend the dark line away.

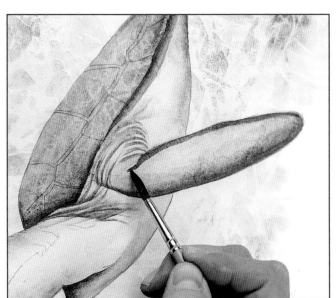

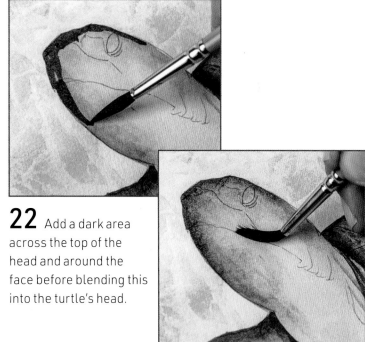

21 Paint a thinner line of the same grey down the opposite side of the flipper. I've rotated my board to make this easier.

22 Add a dark area across the top of the head and around the face before blending this into the turtle's head.

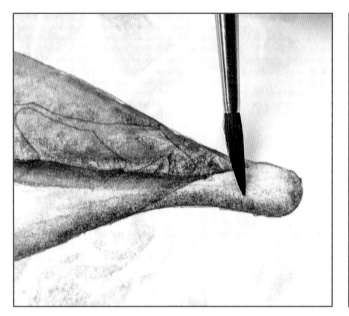

23 Add a grey shadow around the edge of the tail and blend it inwards.

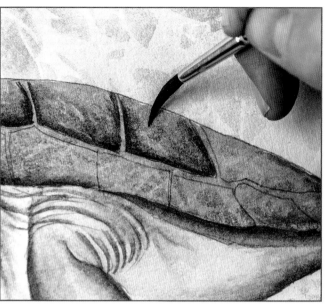

24 Use strong natural grey to paint an outline on each shell segment, working on one at a time and blending the line into the segmented area with a damp brush.

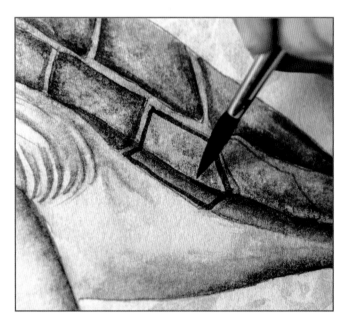

25 For segments that go over the edge of the shell, work in the same way with the outline, but following the angle of the change in direction. Clean your brush and blend in the same way.

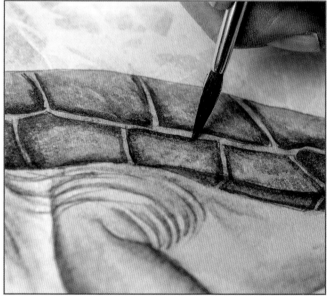

26 Using the same grey, revisit each segment and just gently add a loose outline to some of the edges to sharpen them up.

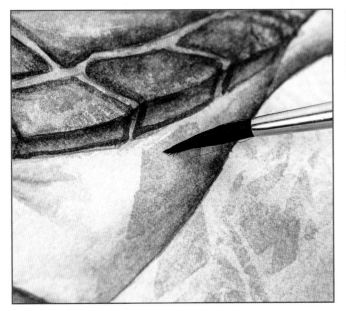

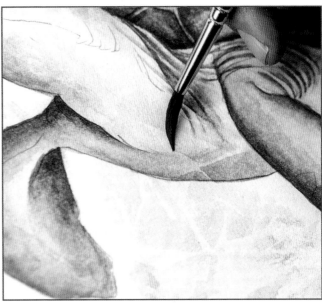

27 Using a diluted pale natural yellow, add a segment on the underside of the turtle. With a clean brush, remove excess water, and blend inwards. With a touch of pale natural brown, pop a few spots inside the segment while the paint is still damp. Allow the paint to bleed.

28 Continue to add further segments to the body in the same way, following the shape of the turtle – notice the shape of the segments where they curve around the edge of the body.

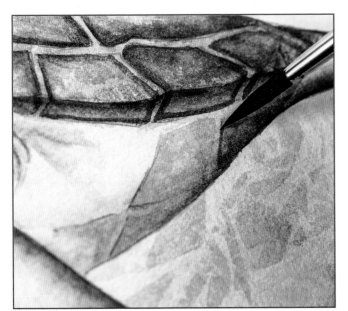

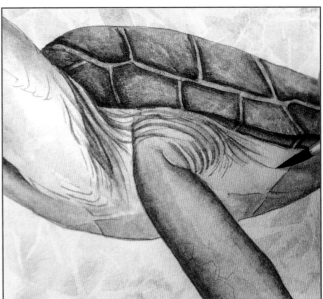

29 Use strong natural grey, removing excess paint to create a dry brush, to add some very fine outlines to the pale segments on the underside of the turtle.

30 Use this same dark grey and the very tip of your brush to add some more definite folds and creases around the base of the neck and around the flipper.

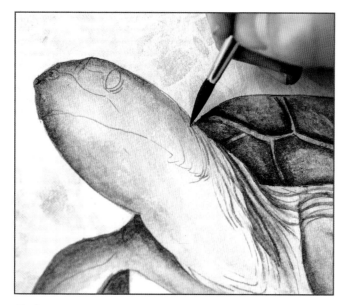 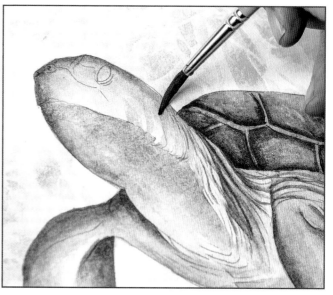

31 Add some tiny lines along the top of the turtle's neck, gradually changing direction to follow the contour of the neck.

32 Using pale natural grey (50% paint, 50% water), add a shadow down the underneath of the neck below the mouth. With a damp clean brush, blend this shadow towards the left of the painting, and start to drag it around the curve of the head.

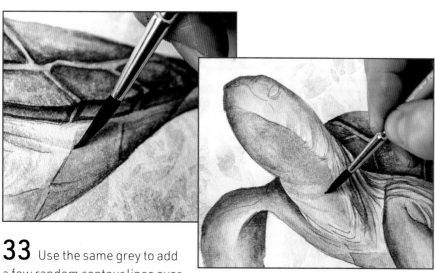 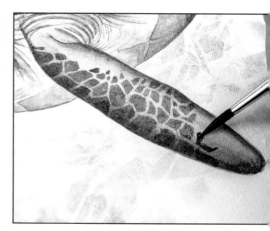

33 Use the same grey to add a few random contour lines over the body. These work well on any flat areas, especially below the shell and underneath the neck.

34 Use a medium-strength brown-grey mix, and use a size 6 brush to gradually work in the markings over the front flipper. These can be painted quite randomly.

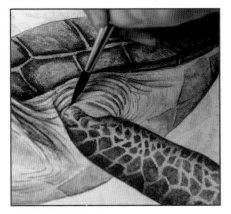 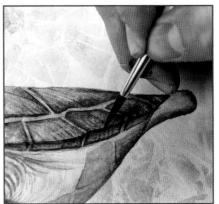 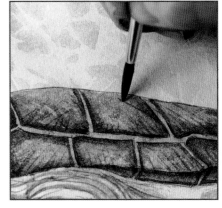

35 Gradually reduce the size of the markings as you work towards the top of the flipper, and merge them into the creases above.

36 Add a few contour lines, working over the top of the shell, following the curve of these. Change direction depending on which part of the shell you are working on.

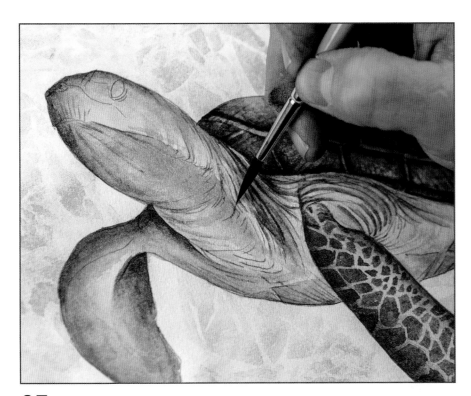

37 Also add these brown lines to the underneath of the turtle, following the curve. Add dry-brush lines going down from the base of the mouth, working down the neck and then upwards from the top of the mouth pointing towards the top of the painting. Add a few curved lines with this brown around the base of the neck where it attaches to the body. Revisit the creases at the top of the flipper with this brown to give extra colour.

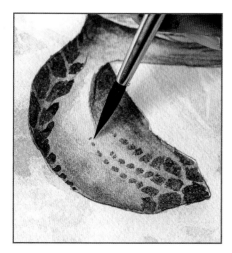 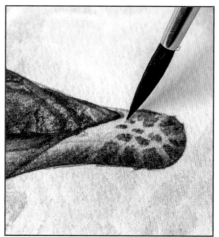 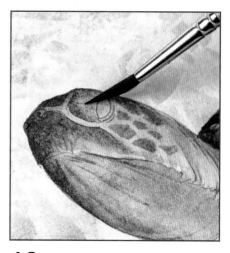

38 Add some brown markings to the other flipper. These slightly curve underneath and taper off down the edge. For the underneath of the flipper, use a more diluted colour by adding a little more water to the paint mix.

39 Using the same diluted brown on a size 6 brush, add a few markings to the tail.

40 Add the markings on the face using the same colour. Take care painting underneath the nose, eye and down towards the top of the mouth. Add a few smaller markings over the head, being careful not to paint over the eye. Blend with the clean damp brush.

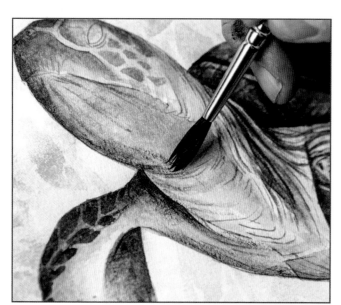 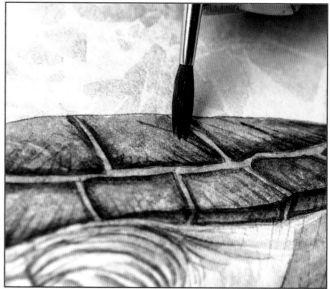

41 Make a strong mix of the brown-grey (80% natural grey, 20% natural brown), and skim the paper with a dry spiky brush to add texture to the neck, following the contour.

42 Use the same dry-brush technique over the shell to give the texture, especially on the edge of each segment.

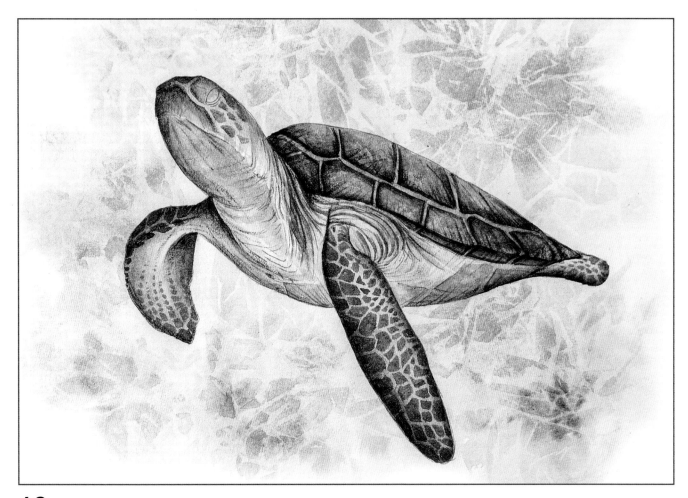

43 Add more detail with dry brush, especially on the shell segments and the lines between them. The markings on the face will benefit from a bit of a dry-brush effect, especially around the nostrils. Continue this technique down the edge of each flipper, to give a slightly shadowed edge.

Tip

This dry-brush technique is a great way to increase the contrast of the shadows, working out from those dark areas. As a basic rule of thumb, for any blank or flat-looking areas, add some contour lines using this dry-brush technique. It is well worth practising on a piece of scrap paper before you try it on your painting.

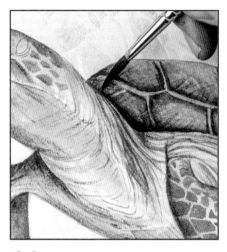

44 Using a size 6 brush with strong natural grey, add a dark shadow to the base of the shell just to the right of the neck. With a clean damp brush, removing excess on tissue, lightly feather this upwards towards the top of the shell.

45 Use the same strong grey to paint in the eye. Paint an outline first, before filling in the bottom section, leaving a lighter section at the top. With a clean damp brush, fill in the eye to give a marble-like effect.

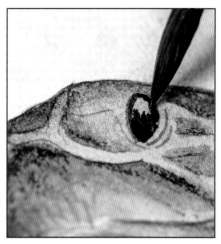

46 Paint two dark spots for the nostrils, and the mouth with a thin grey line which gradually tapers off towards the right. Once the mouth is in place, clean and wipe your brush and gently feather the line down without blending too much.

47 Using the same strong grey, paint a line around the edge of the marking around the eye. Add a couple of wrinkle lines to the bottom of this section. With a clean damp brush, lightly feather these areas.

48 With the same strong grey but working with the tip of a dry brush, add a few final details underneath the nostrils and around the eye. The secret here is to have very little paint on your brush – you are almost scratching the surface with your brush.

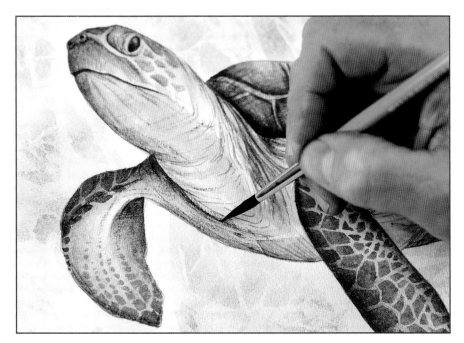

49 Add a darker line down the left-hand side of the neck to give the illusion of the neck protruding from the underside of the body.

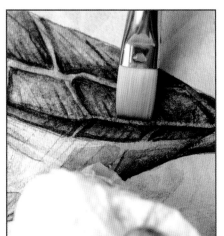

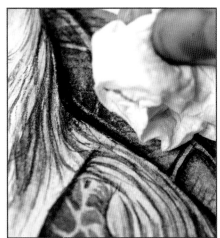

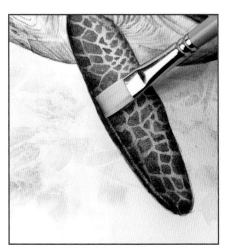

50 Wet a 6mm (¼in) or 12mm (½in) flat brush and gently remove the excess water between your fingertips. Using the tip of your brush, add a highlight on the edge of the shell. Keep refreshing the brush in the water and pinching it through your fingers before adding further highlights. Add a highlight to the dark area of the shell to the right of the neck, and another to the left edge of the flipper.

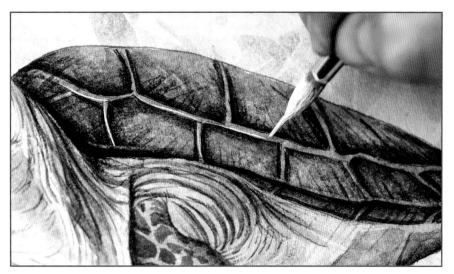

51 Use some white opaque paint on the tip of a size 1 rigger brush to add a tiny white highlight between each segment over the shell.

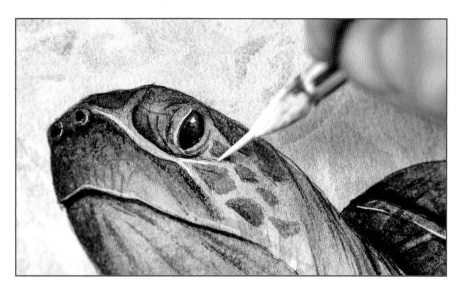

52 Add a dot of white paint to the eye, and some white lines just above the mouth, around the nostrils, along the eyelid, and add a few white lines in between the brown markings on the face.

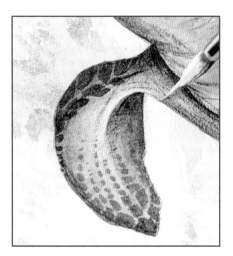

Tips

See page 38 for more on using white paint.

If any white lines are looking too harsh, use a size 6 brush, removing all the excess water, and blend the lines softly into the painting.

53 Add a white highlight to the fold in the left-hand flipper, and a few lighter areas in the creases to the right of the neck.

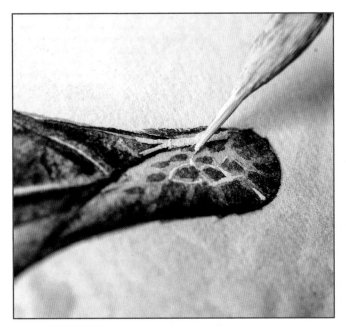

54 Add a white line on the back of the shell, where it meets the tail, followed by a few white lines between the segments on the tail.

55 Working with a dry brush, removing excess white paint on kitchen paper, add a few quick flecks of white paint to the shell segments to give added texture, following the direction of the shell.

56 Finally, paint a line underneath the white tip at the end of the shell – this is done with strong natural grey.

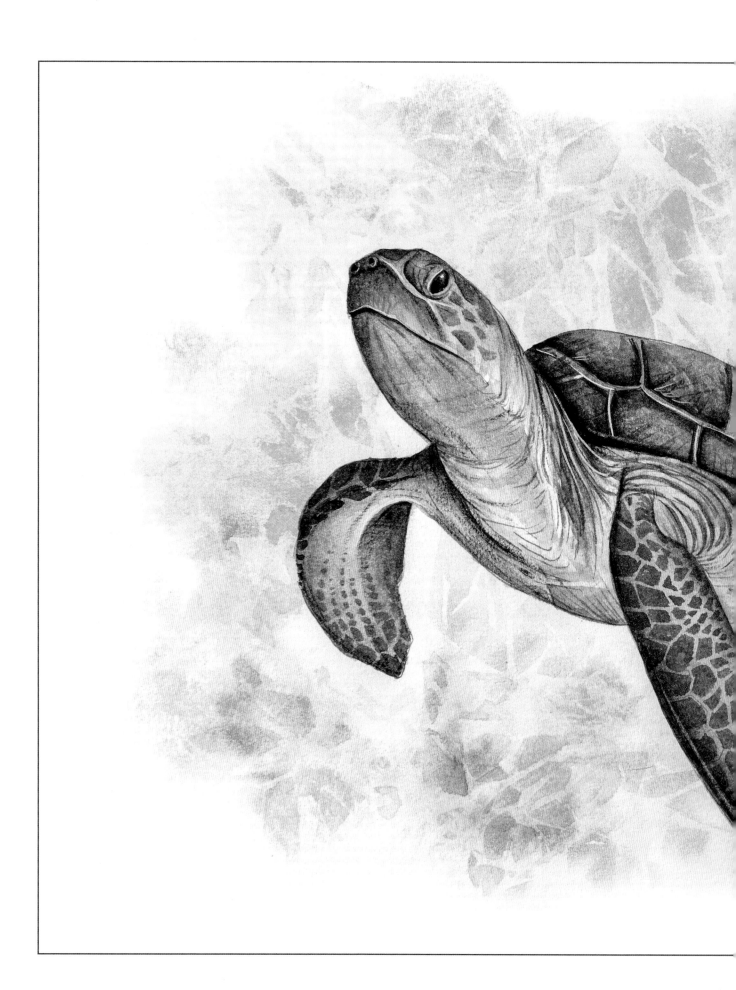

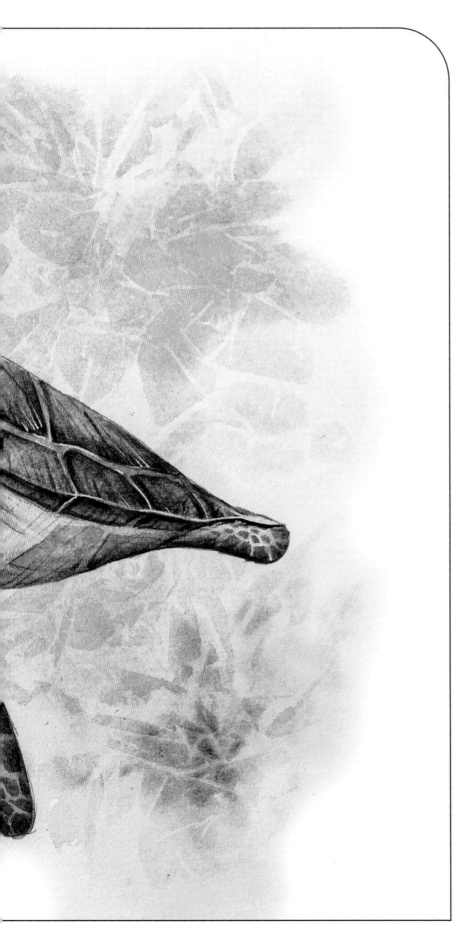

The finished painting.

Panda

A detailed close-up of a panda eating bamboo. As with the majority of the projects in this book, the panda is painted in a vignette background, with soft faded edges. The detail in the panda's face is the key to making the composition work. Adding the bamboo creates an immersive natural setting. In this project you will learn how to paint fur, wet-into-wet backgrounds, add character to facial features and paint a vignette.

When you're ready to begin, transfer the outline to your paper and use a size 20 brush to wet the entire page twice.

Outline 9

You will need:

Brushes: size 6, 10, 20 round, 6mm (¼in) flat, rigger size 1

Paint colours:
natural grey
natural yellow
natural brown
natural green
natural green light
natural yellow light
opaque white or white gouache

Other: kitchen paper

1 Start off with the natural yellow light and twist a size 20 brush to paint in the background, loosely avoiding the panda. Rotating the brush will give a nice out-of-focus look. Go straight into the natural green light – no need to clean the brush – again loosely avoiding the white parts of the panda and allowing the green to mix with the yellow.

2 Clean the brush, and while the background is still wet, add the natural green by twisting the brush around the head area of the panda. Use a size 10 brush with the same natural green, dab the brush on kitchen paper, and add lots of diagonal or vertical lines to represent some background foliage. Take a piece of kitchen paper and gently tap off any excess green paint that is overlapping areas of the panda.

3 With a size 10 brush, use the strong natural grey and start to paint in the dark parts of the panda's fur, allowing the paint to fade towards the edge of the picture. This paint can be softened with a damp brush, removing excess water on kitchen paper if needed. Allow the paint to spread and bleed into the background. Clean your brush and use a damp brush to blend any hard areas of grey, working outwards towards the bottom of the picture. Keep blending inwards to the body of the panda, and keep refreshing your brush in water as you go.

4 Using an extra-strong natural grey, add some darker areas. These are at the left and right sides of the paw, and running up the side of the neck, as well as on the left and right sides of the bamboo shoot, and on the underneath of the paw, creating a shadow-like effect.

5 Revisit the ears with this stronger grey to add some extra darkness. Clean the brush, wipe off the excess on kitchen paper, then use the brush to blend away any hard areas, all the time refreshing the brush in the water, removing the excess water and blending. Allow to dry.

6 Using the pale natural yellow light with the size 10 brush, paint in some of the panda's face – this goes to the left and right sides of the mouth/muzzle, blending across the outer edge of the white fur with a clean, damp brush. Add the same colour around the nose and slightly working back up the bridge of the nose towards the top. Clean the brush, remove the excess on tissue and fade away into the white. Use the same colour down the right side of the picture on the white area of the panda. Repeat the blending process. Leave to dry.

7 Mix a pale colour from natural yellow and natural brown, and add this slightly warmer colour below the mouth under the chin. Blend away with a clean, damp brush.

8 Use the same colour to add a line across the top of the nose on the white area slightly pointing towards the top of the picture. Clean the brush, remove any excess water and blend into the face.

9 Use the same colour to add a line on the bottom section of the mouth and blend this down towards the bottom of the chin.

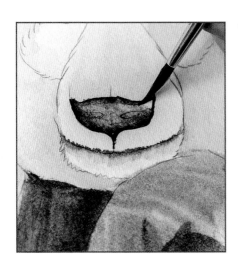

10 Switch to a size 6 brush and pick up strong grey, and lightly tap in the darkness of the mouth, working the brush across the mouth area in a series of tiny diagonal lines. Blend this down really well towards the chin using a clean, damp brush before painting the nose. Next, outline the nose in strong grey – make the bottom section of paint wider. With a clean, damp brush, connect all of the nose together by scribbling the damp brush in the area inside the outline.

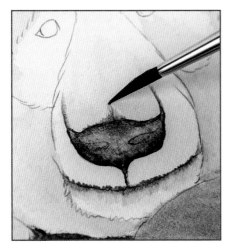

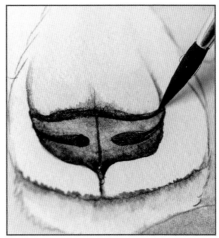

Tip

Rotating the brush through the palette is a good way to make the brush point sharper.

11 Clean your brush again, this time wiping the brush almost dry on kitchen paper, and paint in the two sides of the nose – taper these back into the white fur. Do the same below the dark line that runs centrally up the nose. Lightly feather the edge upwards in the centre. Allow to dry.

12 Use the strong colour to paint in the nostrils of the panda. These nostrils curve round the corner (almost like a fish swimming in a pond). Paint a thin line down the centre of the nose and a wide line across the bridge at the top.

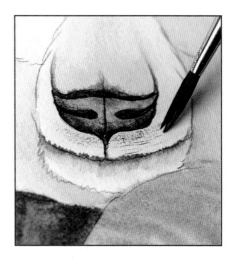

13 Using this splayed bristle and the tip of the dry brush, lightly skim across the surface of paper, utilizing the grain of the paper to give texture to the fur.

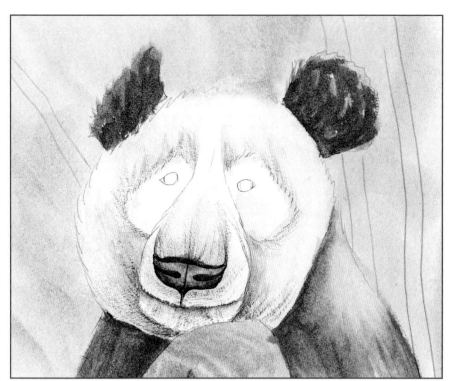

14 Using the same dry brush with splayed bristles, and the same strong colour, add some dry-brush strokes around the bottom of the nose, curving around each side, and around the dark part of the mouth, around the bottom lip. Add more dry-brush strokes around the chin and on the large white areas. Blend in any obvious dark lines with a damp brush, removing excess water on kitchen paper first.

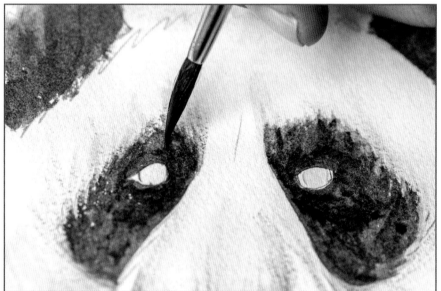

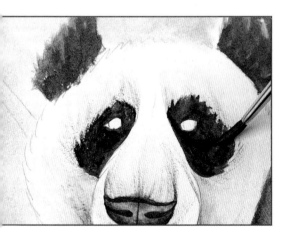

15 Using a size 6 brush and very strong grey, paint in the dark patches around each eye – follow the line of the mouth and nose area and very carefully leave a white space for the eye.

16 With a clean, damp brush, lightly feather the outside edge with small flicks of your brush to create a grass-like edge, before using the same grey to add some darker depth around the eye, overlapping the dry background colour.

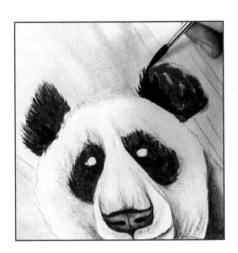

17 Use a strong natural grey and a size 6 brush to build up the dark areas on the ears with a dry brush. The stronger the paint the better. Try to use only the point of the brush to add a furry edge.

Tip
Leaving the occasional light area from the background colour will give more variation and shadow into these areas.

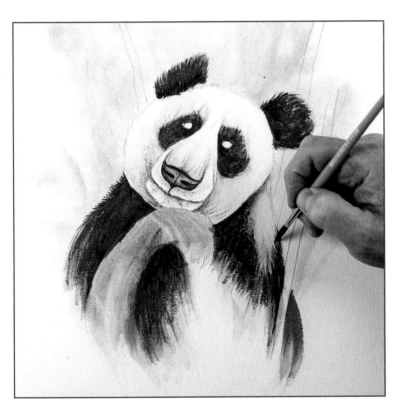

18 Using the same technique, work down into the body of the panda. Start on the left side of the painting, being careful not to paint over the paw. Work across towards the right-hand side of the painting, making this dark area more solid, and with less of a dry brush, working up cleanly against the edge of the bamboo pencil line. Working on the right-hand side of the panda, add some texture to the fur using the same dry-brush effect. Almost drag the brush down using the side of the bristles. This has the effect of only some of the paint touching the paper, picking up the texture on the surface of the paper.

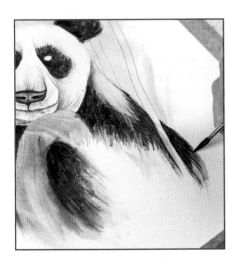

19 Repeat this effect on either side of the bamboo canes. Try to fade this dark paint towards the bottom to create a vignette effect. Having less paint on your brush will help this look more natural. Keep the brush moving nice and quickly to give a natural feeling to the brush strokes.

20 Add little flicks using the tip of your brush to represent individual hairs. If you find a size 6 brush too large for this detail, feel free to change to a size 1 rigger or branch and detail brush.

21 Using an extra-strong grey (90% paint with just a touch of water), work back around the eyes almost in a semi-circle shape from the bridge of the nose working towards the outside of the head. This helps to give shadow.

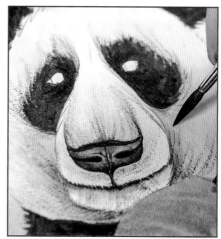

22 Using the same extra-dark grey, and a very dry brush, add greater darkness to the inside of the nostrils, the bottom of the nose and in the dark part of the mouth. Using the tip of a rigger or branch and detail brush, add a few directional lines suggesting hairs on the white parts of the panda.

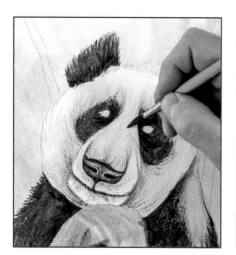

23 These lines follow the contours of the panda, working under the bridge of the nose, around the cheeks, and allowing the brush to follow the shape and form of the face.

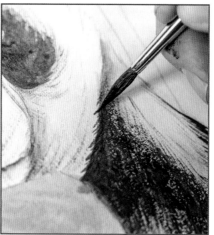

24 For any hard contrast lines where the white meets the dark, especially around the neck, use the dark paint to add a grass-like edge to give the impression of the panda's fur.

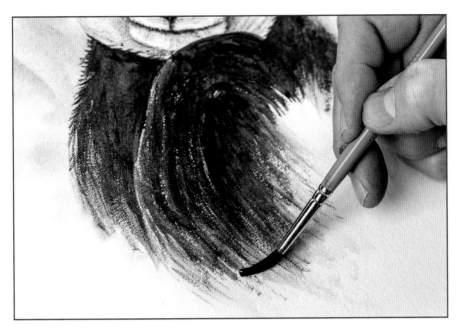

25 The final dark area is the paw. Add several directional brush strokes with a strong natural grey. Blend any harsh lines using a damp brush. Allow to dry.

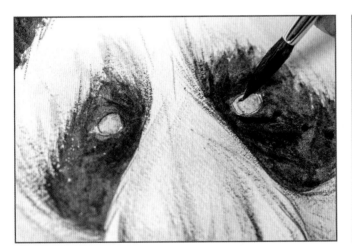

26 Mix natural yellow light with a touch of red, and then a touch of blue to make pale brown for the eyes. Use this with a size 6 brush and fill in both eyes. While it's slightly damp, pick up the strong grey and pop a few spots around each eye, especially across the top.

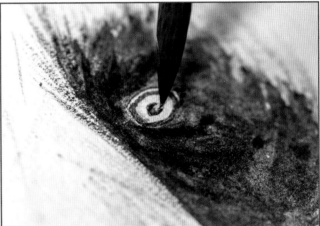

27 Using strong natural grey with the tip of a size 6 brush with a good point, paint a dark ring around the centre of each eye, around the edge of the brown, leaving a slight edge. Add the pupils to the eyes as tiny 'C' shapes, and then use a damp brush to lightly complete the circle.

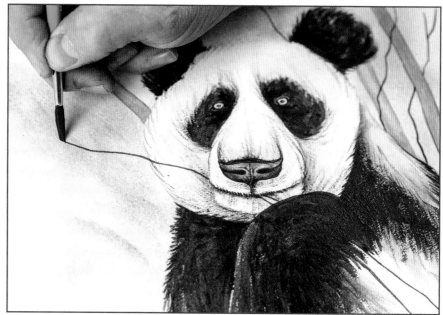

28 Use the pale brown mix to paint the bamboo canes. Outline them first, and then use a damp size 6 brush to blend the bamboo outlines into the centre, fading away at the top of the cane. Repeat this effect on each bamboo cane.

29 Use natural green with a size 6 brush to paint in some green stems around the bamboo. Paint these branches going underneath the panda's paw and through the mouth. Add as many as you feel your painting needs.

30 Use the same green to add some segments along the bamboo canes.

31 Flick the darker green to add some leaves to the stems – paint these in one quick motion with your brush, and try using the side of your brush to give more width. Rotating the board will help to give more variation to the leaf shapes. Add some leaves hanging down from the panda's paw.

32 Using the same dark green, pinch the brush almost flat and add some texture to the main bamboo stems. Skim the brush upwards along the bamboo canes. Only a little bit of texture is needed here.

33 Add some lighter leaves to the bamboo using the light green mix. Add a finishing touch to the leaves – add a few random lighter leaves around the edge of the painting to give a nice vignette effect.

34 Using the tip of a 6mm (¼in) square brush with a tiny bit of water, add a few highlights to the panda. Start with the ears, and use some kitchen paper to lift off the paint as you go.

35 Repeat this highlight effect around the side of each eye, almost in a 'C' shape.

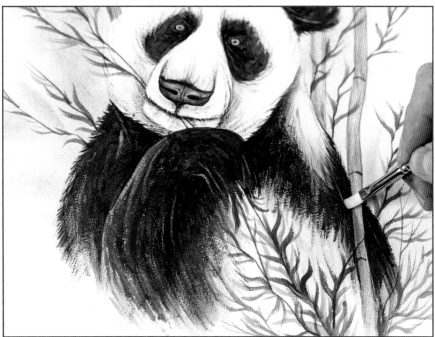

36 Add some highlights to the top of the paw, where it meets the dark part of the panda's body, to the end of the paw and to the left and right sides of the body, trying to follow the contour where possible. Add highlights in the same way to the bamboo and leaves.

37 The final highlights are added with opaque white watercolour and a tiny amount of water on a size 1 rigger brush. Add lots of fine hairlines, especially overlapping the dark areas, such as the ears, eyes, mouth and body.

38 White is particularly effective over the mouth and around the chin.

39 To help the panda stand out against the green background, some white flicks can be added around the pale edges, painted quite loosely.

40 Add a few white flicks across the top and bottom of the paw, following the direction of the fur.

41 Add subtle fine lines around the eyes, following their circular shape. Work over the top of each eye, adding a fine highlight to the side of each pupil, and paint a very fine broken line around the edge of each eye to really bring the eyes alive. Finally, add some white highlights around the nostrils, a fine line down the centre with the nose and across the top of the nose.

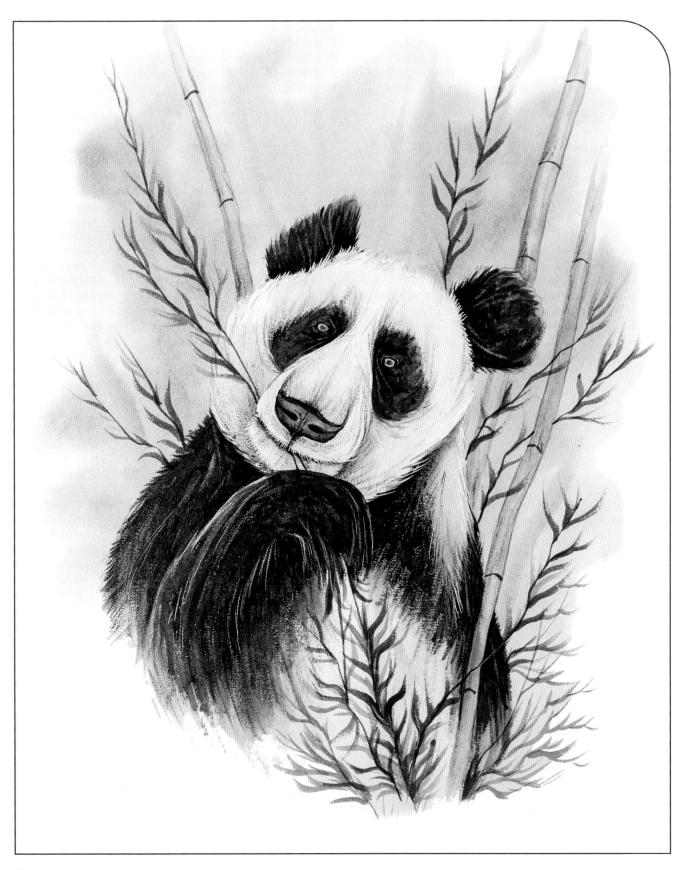

The finished painting.

Polar bear

This polar bear against a gorgeous Arctic landscape makes for a beautiful watercolour painting. The falling snow is created using table salt to make the scene look more natural and realistic. In this project you will learn how to paint a landscape, paint reflections, work with a dry brush and add falling snow.

When you're ready to begin, transfer the outline to your paper and use a size 20 brush to wet the entire page twice.

You will need:

Brushes: size 6, 10, 20 round, 12mm flat

Paint colours:
 Prussian blue
 natural violet
 natural orange
 natural grey
 natural turquoise
 natural yellow
 opaque white or white gouache

 Yellow-brown, mixed from natural yellow with a touch of natural brown

Other: kitchen paper, fine sandpaper, masking tape, salt, craft knife

Tip

Note that Prussian blue tends to stain a lot!

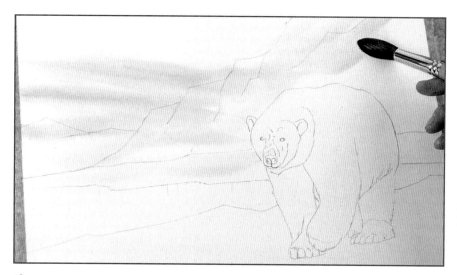

1 Start at the base of the sky and add horizontal brush strokes of natural orange with a size 20 brush. Don't be afraid to add this over the top of the icebergs.

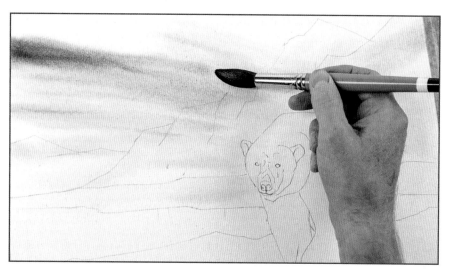

2 Next, add strokes of natural violet slightly above the orange, working into the iceberg.

128

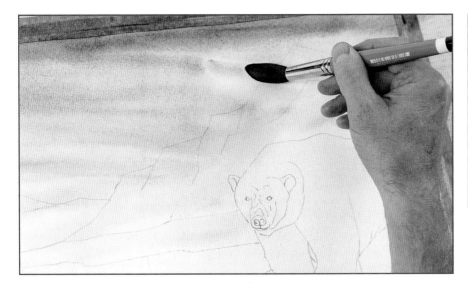

Tip

Violet is used between the blue and yellow paint for the sky to prevent the colours bleeding into each other and creating a green-tinged sky.

3 Add medium-strength Prussian blue across the top of the sky. This is the most important colour – it gives a crisp sky and works well with salt.

Using salt

Less is more! Sprinkle the salt between your fingers over the area you wish to add the snow effect. Leave for 2–3 minutes, to allow the salt to work its magic, and let it dry naturally. The perfect time to add salt is just as the paint is on the verge of drying. The wetter the paint, the bigger the snowflake this effect creates.

It's a good idea to test the salt technique with your paint on a piece of scrap paper, as not all colours work well with salt.

4 To create a snow effect, lightly sprinkle some table salt over the sky while the paint is still damp. A single grain of salt creates a single snowflake.

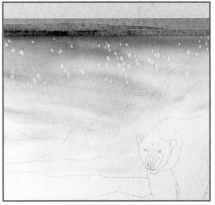

5 Once you're happy with the size of snowflake the salt has created on your painting, you can use a hairdryer to speed up the drying process and prevent the salt from reacting further and creating larger snowflakes than desired. Once dry, lightly brush the salt from the paper.

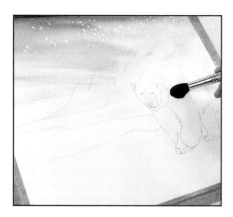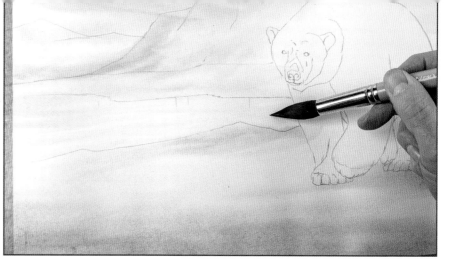

6 Using clean water, wet the paper twice from the sky down to the bottom edge of the paper, using a size 20 brush.

7 Start off by using the Prussian blue to paint the foreground of the picture, working loosely towards the polar bear. Add a few streaks in the background landscape. Clean the brush really well before using violet to add extra shadow to the base of the polar bear and to little areas in the landscape. Blend any hard lines away using a clean damp brush.

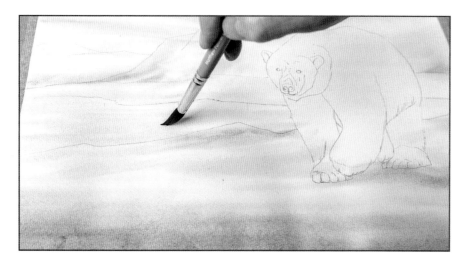

8 Use pale natural turquoise to add some horizontal brush strokes to the water. Use a size 10 brush with a tiny amount of natural orange to add a warm glow to the snow, loosely avoiding the Prussian blue to prevent making a green tinge. Apply orange in horizontal streaks to the water in the foreground. Use a damp brush to blend any hard lines.

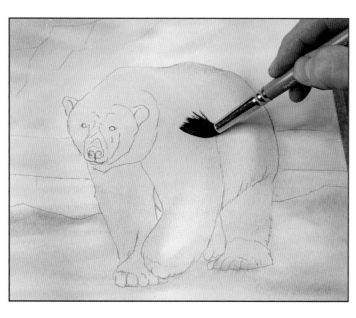

9 Using the size 10 brush with natural yellow, add some colour to the polar bear, almost like an outline all around the body. With a clean brush and excess water removed, blend this inwards towards the body.

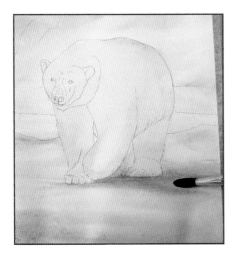

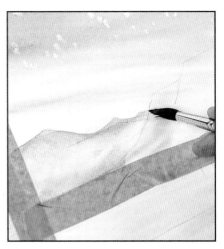

10 Use medium-strength grey and a size 10 brush to paint a shadow cast to the right of the polar bear. Blend this downwards to the right and into the landscape. Allow to dry.

11 Run a piece of masking tape between your fingers to remove some stickiness, and stick it down over the horizon line.

12 Using pale natural grey with a size 10 brush, paint in the background landscape across the top edge and along the masking tape. Clean your brush really well, wipe the excess water on some kitchen paper and blend in the grey with a gentle scrubbing action.

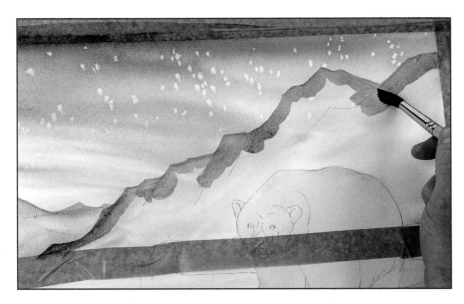

13 Using the same grey, work along the edge of the larger iceberg using a nice wide line to help the blending process. Work all the way to the top of the landscape.

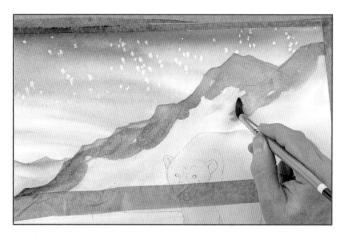

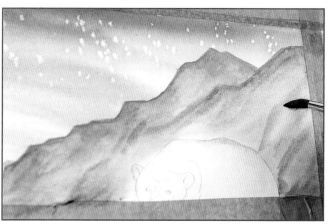

14 Paint in the larger glacier or iceberg with a size 10 brush using a pale natural grey followed by a pale Prussian blue. Work down to about halfway into this area.

15 Blend the icebergs all the way down towards the masking tape. While this area is still damp, add some shadows using a medium-strength natural grey. Paint these using the direction of the glacier.

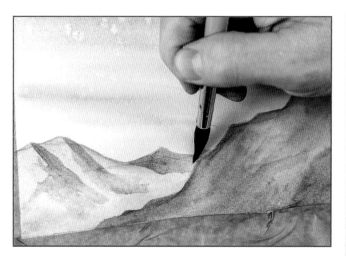

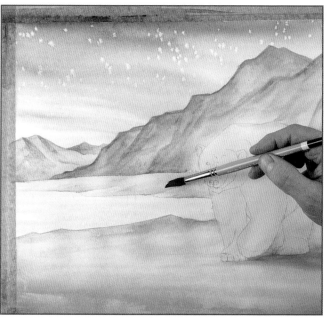

16 Using the same grey, add a few shadows to the background landscape, working down from the peaks. Use a clean damp brush, removing any excess water on kitchen paper, and blend the shadows into the landscape. Allow your painting to dry before carefully removing the masking tape.

17 Using the same brush with the same Prussian blue mix, add some shadows to the bank on the left-hand side of the picture, and paint a line along the top edge of the foreground area, as shown. Very quickly blend this downwards before the paint dries.

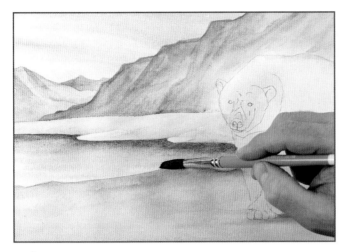 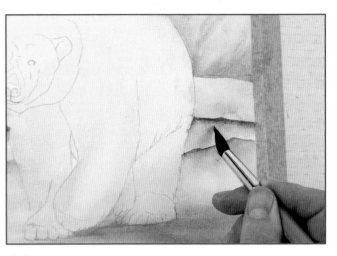

18 Start to paint the water with a strong natural grey and a size 10 brush. Paint a dark line along the water's edge, carefully following the shape of the banking. With a clean damp brush, blend the dark grey line downwards.

19 Repeat this effect on the right side of the polar bear.

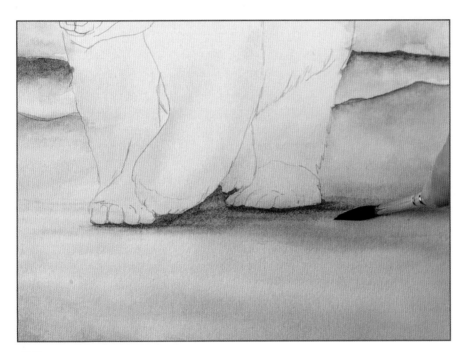

20 Using a size 6 brush and the same strong grey, paint a dark shadow along the bottom of the polar bear's feet. Blend the dark grey shadow away to the right. This gives a lovely base to the polar bear.

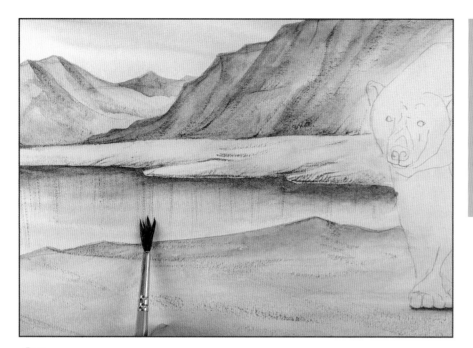

Tip

It's important to add these dry lines to follow the contour of the background. Don't be afraid to reload the brush any time, removing any excess paint on kitchen paper and continuing to paint in quick random brush strokes.

21 Mix extra-strong natural grey with just a little water, and load up a size 6 brush, remove the excess paint on kitchen paper, and slightly pinch the brush to splay the bristles. Use this dry spiky brush to add some texture to the glacier, the water's edge and anywhere in the landscape: I've added these details to the glaciers, foreground and as some reflections in the water.

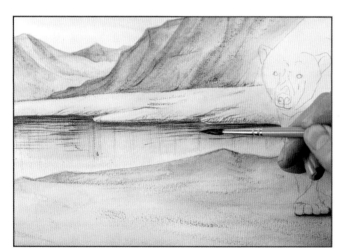

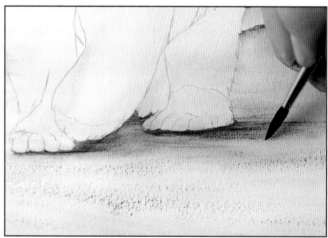

22 Using the tip of a size 6 brush with the extra-strong grey, add some dark horizontal ripples from the banking, working down to the bottom of the water. These need to remain horizontal throughout on both sides of the polar bear.

23 Paint a few horizontal lines over the shadow underneath the polar bear to give texture to the ice.

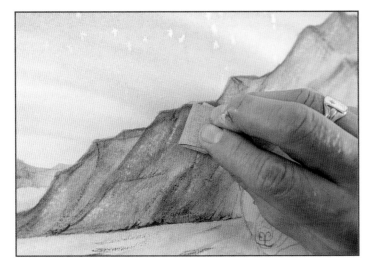

Tip

Sandpaper is a great way to blend in some hard lines, but you can also create highlights by adding firmer lines. Simply fold a small piece of fine-grade sandpaper into a crease and work some harder lines into the painting to create textured lines.

24 Take a piece of fine sandpaper and work over the icebergs and any other areas that need blending. Press firmly onto the painted surface.

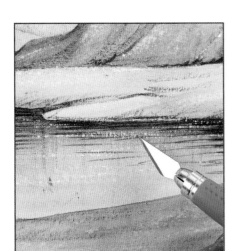

Tip

You need to apply a lot of pressure when using a craft knife. Don't be afraid to dig deep into your painting to create the effect.

25 Next, use the fine tip of a sharp craft knife to scrape some horizontal highlights into the water and to add some light directional highlights to the glacier.

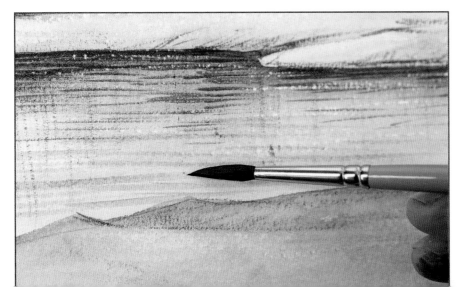

26 Finish off the landscape section of this painting with a pale natural grey and a size 6 brush to add some horizontal ripples to the water.

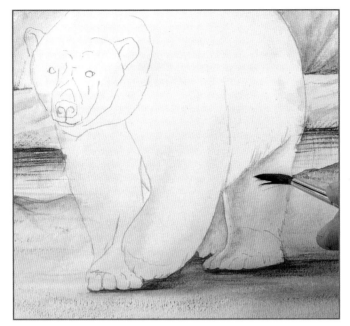

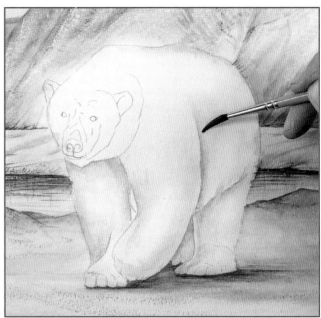

27 Using a mixture of natural yellow with a touch of natural brown, work with a size 6 brush to paint in the back legs, blending thoroughly.

28 Start to outline the front legs in the same way. It's important to follow the contours of the animal for successful blending. Add a line where the belly meets the front leg and blend this in with water.

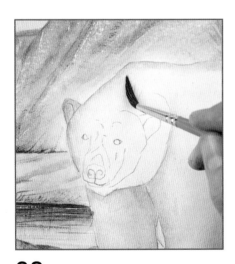

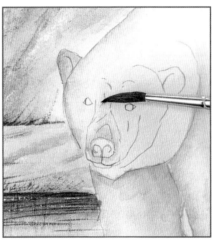

Tip

To give the polar bear's fur a natural look, blend these shadows downwards and away to nothing at the ends. Drag the damp brush through the top of the shadow to intensify the fur-like edge.

29 Add a further shadow from the left-hand side of the face, over the ear and over the head. Blend smoothly towards the polar bear's back.

30 Add a shadow around the nose and mouth area, working up towards the muzzle. Blend this away with a clean damp brush.

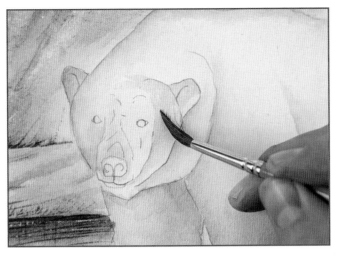

31 Add another shadow on the right-hand side of the face and over the right ear. Blend smoothly in the same way.

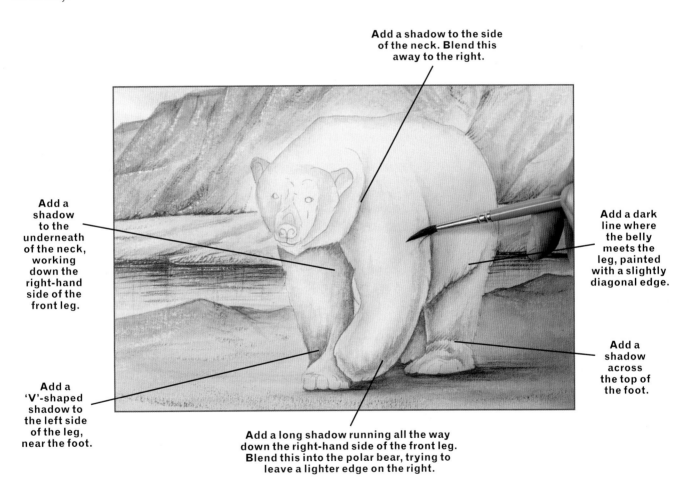

Add a shadow to the side of the neck. Blend this away to the right.

Add a shadow to the underneath of the neck, working down the right-hand side of the front leg.

Add a dark line where the belly meets the leg, painted with a slightly diagonal edge.

Add a 'V'-shaped shadow to the left side of the leg, near the foot.

Add a shadow across the top of the foot.

Add a long shadow running all the way down the right-hand side of the front leg. Blend this into the polar bear, trying to leave a lighter edge on the right.

32 With a size 6 brush and medium-strength natural grey, add some dark shadows to the polar bear, as shown, to begin to give the muscular form. Blend each shadow using a damp brush.

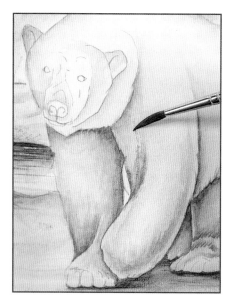

33 Add a 'V'-shaped shadow to the left side of the large front leg; this helps to create a fold in the fur. Clean the brush, remove the excess water and blend this away into the animal using the same techniques before.

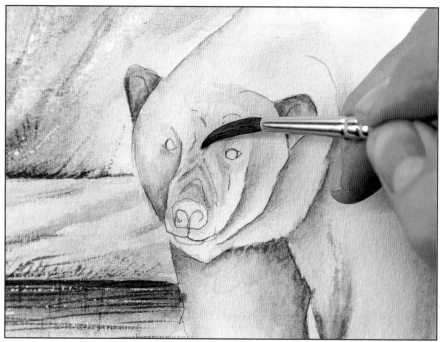

34 Add grey shadows to the face, each ear, on either side of the mouth, and add a 'C'-shaped shadow around the left side of the right-hand eye. Blend these into the fur. Paint some 'V'-shaped shadows over the top of the nose. Use a damp brush to blend these in, following the shape of the head.

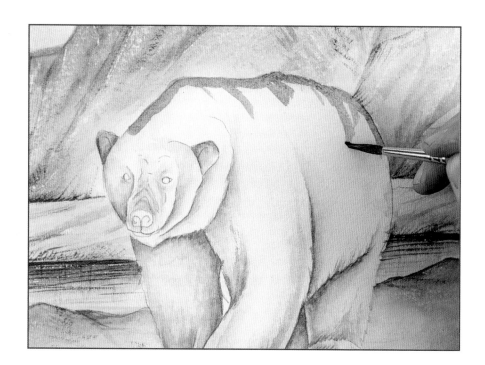

35 Paint a grey line all the way across the top of the polar bear, working down towards the back, following the curve of the polar bear's body. Blend these lines downwards with a clean, damp brush.

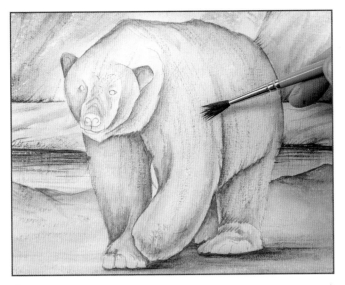

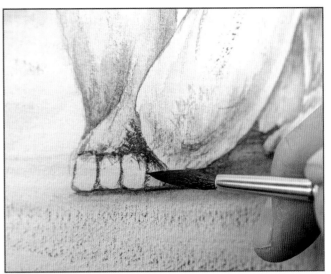

36 Using medium-strength natural grey and a size 6 brush with splayed bristles, add texture to the fur. Drag the brush over the polar bear, working in long strokes down the body, legs and face in light brush strokes, following the direction of the body. Pay extra attention to the feet.

37 Use a slightly stronger grey with the same dry brush, this time keeping the bristles pointed. Paint some dark separation lines between the toes.

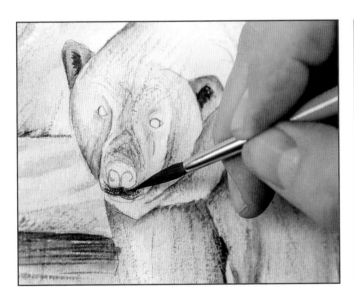

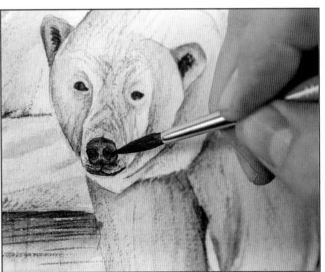

38 Use the same dark dry brush to add the dark centres to the polar bear's ears, and paint in a dark, almost moustache-like shape underneath the nose of the bear, using the same dry-brush effect. Add a dark line for the mouth.

39 Switch to a rigger brush and paint in the eyes and nose as a solid dark colour. Then use a strong dark colour to add two large nostrils.

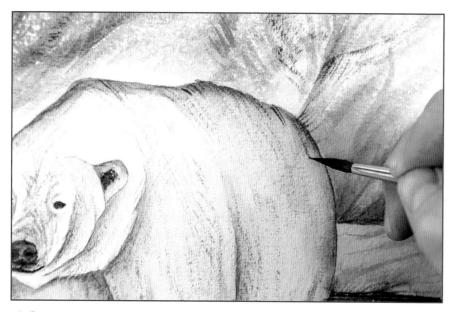

40 Some flicks with this strong grey can be added across the top of the polar bear, and anywhere to increase contrast next to some of the light areas.

41 Use a 12mm (½in) flat brush with a tiny bit of water to add as many highlights as your painting requires – this is simply washing off the colour with the tip of your brush and wiping away the washed-off colour with kitchen paper.

42 These highlights work well following the shape of the polar bear's back. Add a highlight to the edge of the legs where the dark meets the light, and even a few highlights within the landscape using the same method. Keep refreshing your brush in clean water, scrub and dab with kitchen paper.

43 Decant some white paint onto a piece of scrap paper. Use a size 6 brush with a good point to paint in some of the crisp white areas of the polar bear – this will really brighten up the scene.

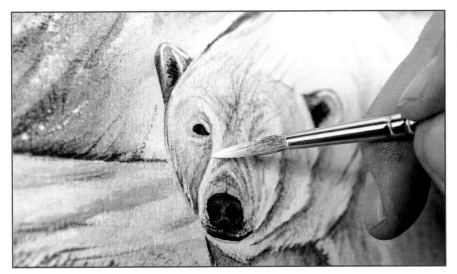

44 With a dry brush, removing excess on kitchen paper, a white fur texture can be added to the polar bear, by dragging the brush across the paper. Add areas of white around the muzzle, mouth and nose area. Add a white highlight on the left side of the nose to make the head stand out.

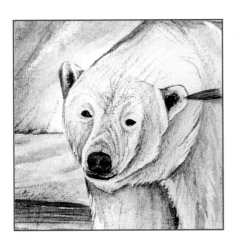

45 Add a white highlight to the edge of the polar bear's ears. This will really make them stand forward against the background. Lightly soften the white inside the ears with a damp brush.

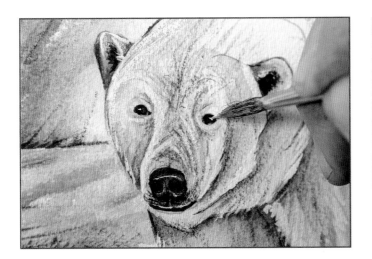

46 Highlight the eyes with a dot on each. Add highlights on the black part of the nose, across the top of the nose, and across the top of the mouth. Use a rigger brush to paint these details.

Tips

See page 38 for more on using white paint.

A useful tip when using white: if the paint disappears once dry, make the paint thicker with less water.

Adding white to the polar bear creates depth to the fur, and takes away the yellow tinge.

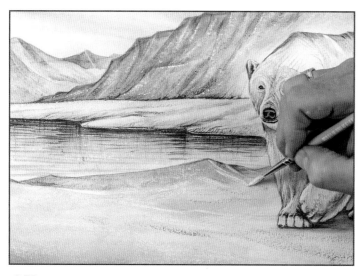

47 Add some white to the foreground using the dry-brush technique.

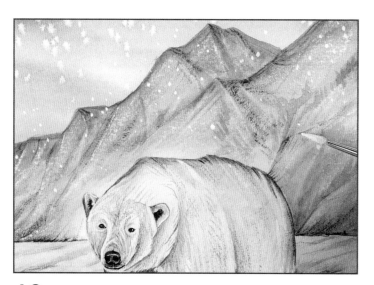

48 To finish off, with your brush, add some white spots of snow from the sky over the whole glacier in the background, not too close to the bear. Don't add too many, just enough to give the impression of distance between the bear and the glaciers in the background.

The finished painting.

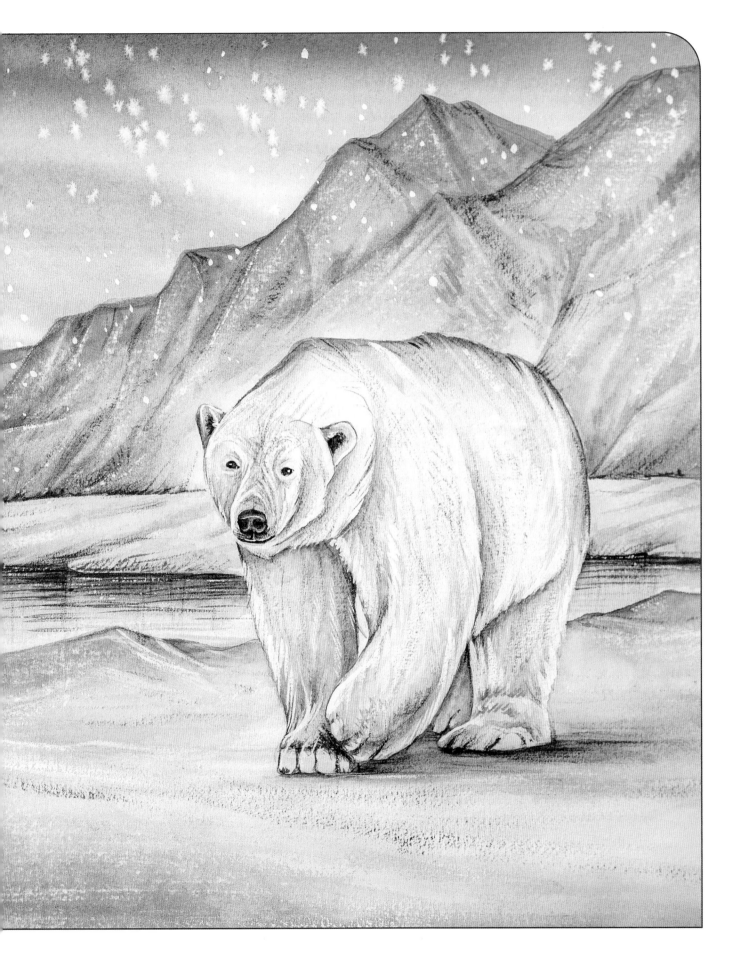

Giraffes

This final all-round project, which features almost every technique used throughout this book, is a great place to complete your watercolour animal painting adventure. The strong use of white paint, highlights and the soft background create a beautiful composition. In this project you will learn how to paint distant landscapes, foliage, markings, details on animals, vibrant shadows, vivid highlights and add facial detail.

When you're ready to begin, transfer the outline to your paper and use a size 20 brush to wet the entire page twice.

You will need:

Brushes: size 6, 10, 20 round, 6mm (¼in) or 12mm (½in) flat, rigger size 1

Paint colours:
 natural blue
 natural yellow
 natural yellow light
 natural green
 natural green light
 natural red
 natural grey
 natural orange
 natural brown
 opaque white or white gouache

Paint mixes:
 red-brown, mixed from natural brown (50%) with natural yellow (40%) and a touch of natural red (10%)
 orange-brown, mixed from natural brown (70%) with natural orange (30%)

Others: kitchen paper, piece of scrap card with a straight edge, masking tape

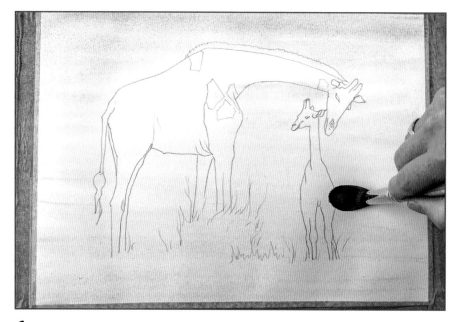

1 Starting with the natural blue, paint all the way across the top of the page, loosely avoiding the pencil outline. Work in horizontal brush strokes to allow for a smooth sky, and paint to about halfway down the scene. Clean your brush really well and pick up some natural yellow light. Work from the bottom upwards and allow the two colours to gently blend in the middle to create a graduated wash.

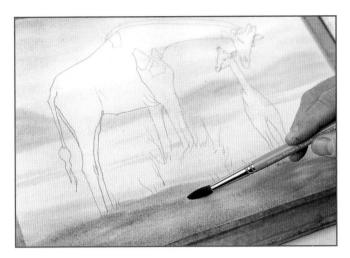

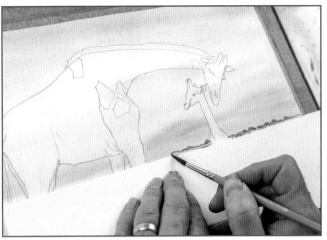

2 Use medium-strength natural green on a size 10 brush to paint horizontal lines across the centre of the page and to create the distant landscape. Add some further green to the foreground before using strong natural grey to add some shadows to the base of the giraffes, working horizontally just below the feet. Allow to dry.

3 Use a piece of card as a straight edge and, with a size 6 brush with a medium mix of natural green, gently rotate the tip of your brush against the paper, being careful not to paint over the giraffes. Alter the sizes of these twists, down to a little tiny spot, to give variation in the landscape.

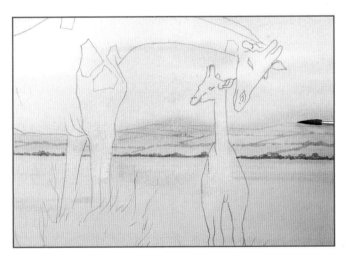

4 Add a touch of water to the green mix and paint in some lines in the far background. Twist the brush and use just the tip to add the occasional spot to represent distant trees. Allow these lines to almost disappear into the misty landscape.

5 Using a stronger natural green and the piece of card, add the occasional touch of detail, using the tip of your brush. These can be quite random, as long as they're horizontal along the card.

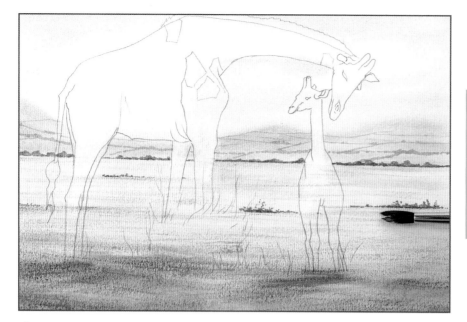

Tip
This dry-brush technique is best painted in quick horizontal strokes. Practising the technique first is always advisable.

6 Using natural green mix and same brush, splay out the bristles with your fingertips. With the spiky brush, work quickly to add horizontal dry lines across the landscape to help give more texture and depth to the scene. Don't be afraid to go over the giraffes' feet at this point. Next, use a medium-strength natural yellow to add some final splayed dry-brush strokes to the mid-ground of the landscape to give a slightly warmer colour. Work up towards the distant hills. Allow to dry.

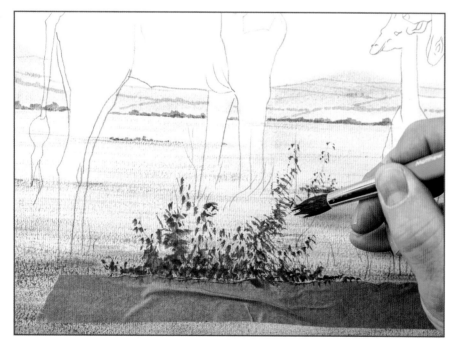

7 Run a piece of masking tape between your fingers to remove some stickiness, and stick the tape just below the foliage, giving a random edge. Use strong natural green on a size 10 brush and stipple the brush through the palette to clump the bristles, creating a spiky brush. Tap the spiky brush gently against the paper, using the masking tape as an edge. Rotate the brush at different angles and work along the masking tape and upwards towards the giraffes' feet. Use the same effect with a strong natural grey to add some dark shadows to the base of the foliage.

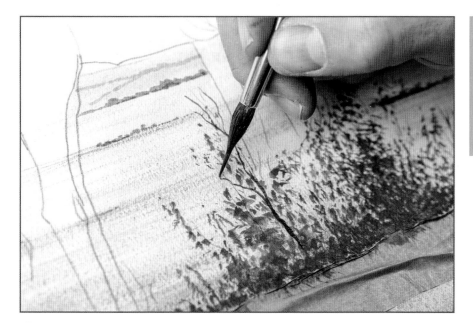

Tip

The best way to use a rigger brush is to hold the brush near the tip, rest your hand on the paper and use it like a pencil rather than a brush.

8 Use a strong mix of the re-brown to add in some brighter coloured foliage. Then use a size 1 rigger, mix a medium natural grey with 10% natural brown and paint in some fine branches, twigs and grass to this area.

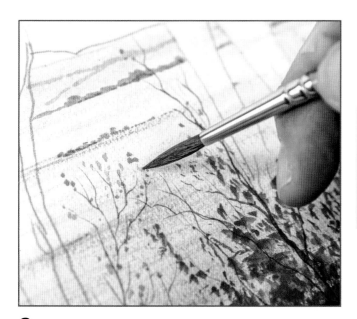

Tip

To prevent rips when removing masking tape, use a hairdryer first – the heat softens the glue to help it come away from the page more easily.

9 Paint in some tall grass with the same brush and the natural green. Using natural green light, add little spots of random leaves with the tip of a size 6 brush – this will finish off the foliage area in the foreground. Carefully remove the masking tape.

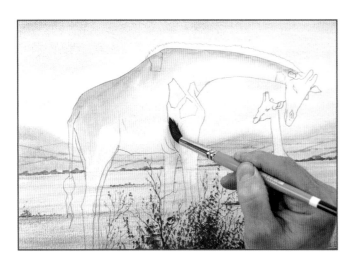

10 Using the mix of natural orange with natural brown and a size 10 brush, paint a wide line across the top of the large giraffe. Gradually taper this in width towards the head. Blend this down towards the bottom of the giraffe using a clean damp brush. Keep refreshing the brush in water until the line is completely blended in.

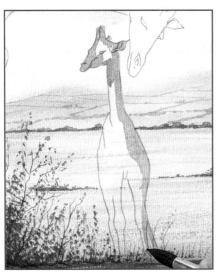

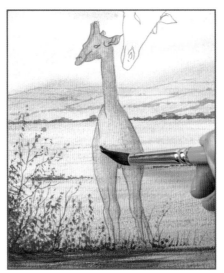

11 Use the same colour to paint the infant giraffe – start at the head and work down the right side and down one side of each leg.

12 Using water, removing the excess on kitchen paper, blend all this colour across the whole of the infant giraffe.

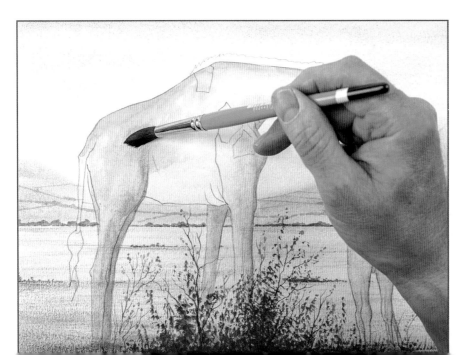

13 Using the same colour on the adult giraffe, paint a line across the base of the neck and down the right side of the front leg and blend. Repeat on the other legs, head, face and neck – all the time painting a line on one side, and blending into the animal. Keep refreshing the brush in the water to make the blend smoother.

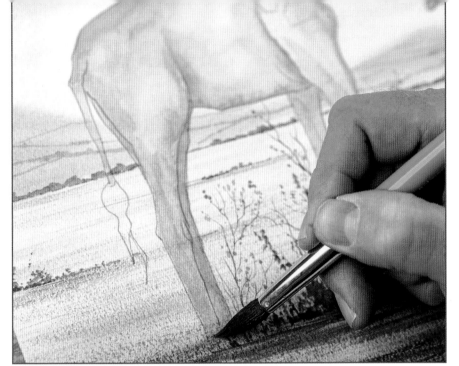

14 Using a pale natural yellow or yellow ochre, paint over the left side of both giraffes, including the tails.

15 Continue with the yellow and paint under the neck of the large giraffe. Clean your brush and blend the yellow towards the right inside the giraffe. Add a few contour lines using the same colour. These loosely follow the direction of the giraffe and blend in with the belly. Paint curves that go around the belly up towards the back, and along the neck.

16 Using a clean damp brush, with excess water removed on kitchen paper, just lightly glaze away those lines – skim the brush over the top of the area to soften them slightly.

17 Add the same curved lines to the infant giraffe – following the shape of the body – to give it more of a three-dimensional look. The lines here create a 'V' shape.

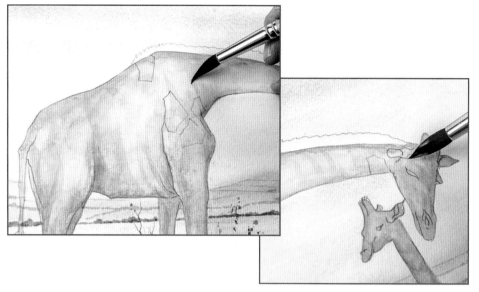

18 Using the same colour, on a dry brush wiped on tissue, lightly sweep over both giraffes to add texture and contour – this has a great effect on the curve on the neck, around the head, and the outside of the legs.

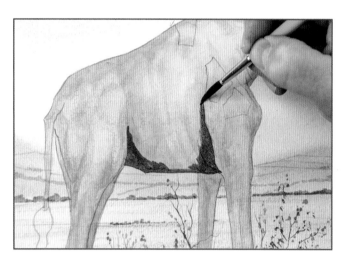

19 Using a size 6 brush and strong natural grey, start to paint in the key shadows for each giraffe, working on one section at a time and blending each shadow away with a clean damp brush. The first shadow is underneath of the belly, which will help to give the curvature of the giraffe's body. Blend this shadow upwards into the giraffe's body.

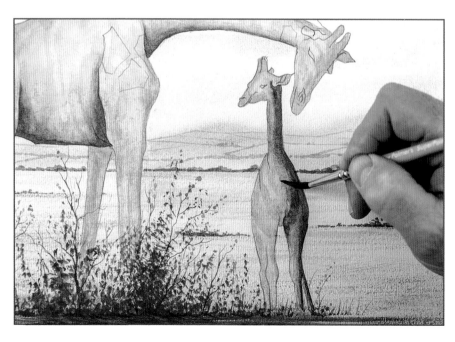

20 Paint a long shadow along the neck towards the head and blend inwards, before moving on to the shadows on the infant giraffe. With a clean damp brush, blend the paint upwards towards the top of the infant giraffe.

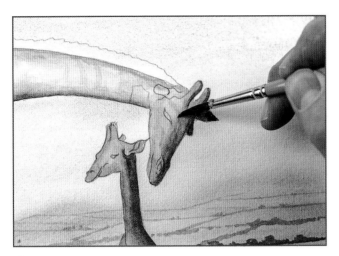

Tips

It's important that these lines are painted in wide, so there's enough paint to be blended away. A good rule of thumb is to paint the line roughly twice the width of the brush: this gives enough paint area to be smoothly blended away.

When adding shadows, it's worth refreshing the brush regularly in the water between each area, wiping the brush on tissue each time.

21 Paint a shadow on the right side of the adult giraffe's head, covering both horns, the ear, over the eye and all the way down the right side towards the nose area. Blend this in using the dry-brush method.

22 Add shadows to the right side of each leg on both giraffes, working down into the foliage, then blend them in.

23 On the young giraffe, this leg shadow goes slightly up into the breast area and runs down the right side of the two legs before it is blended in.

24 Use a strong natural grey and a size 6 brush to paint in the hairy tail of the adult giraffe, made up of individual strands.

Add some curved lines around the top of the leg and around the belly.

Add a line on the infant giraffe on the right-hand leg.

Add some dark lines on the legs.

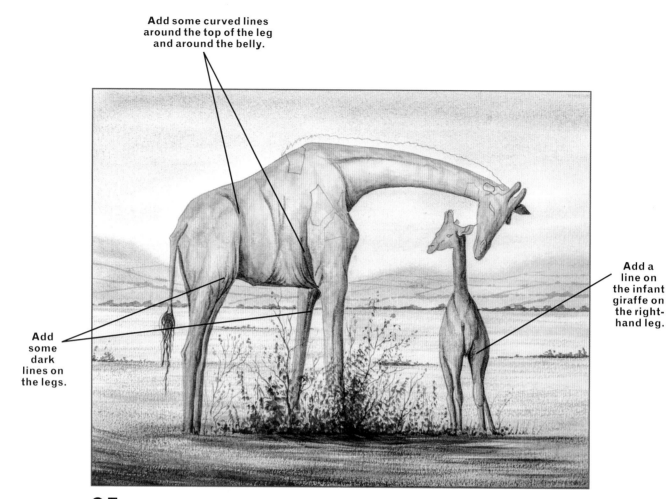

25 Using the same strong grey, removing the excess paint on kitchen paper, paint in some strong dark lines in a few areas as shown, to give extra sharpness to the giraffe. All of these lines can be slightly softened with a clean, damp brush.

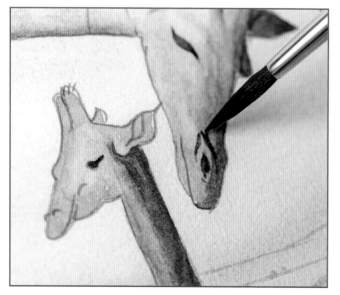

26 Paint the eyes and nostrils with strong natural grey. A branch and detail brush is a good option for this. With a clean, almost dry brush, feather the shadows in the nostril. The mouth is simply painted with a strong grey line on both giraffes and then feathered away with a damp brush.

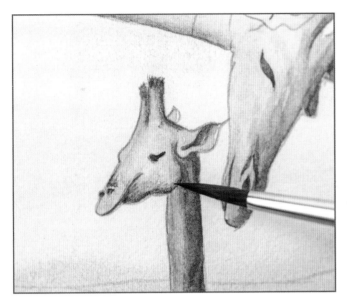

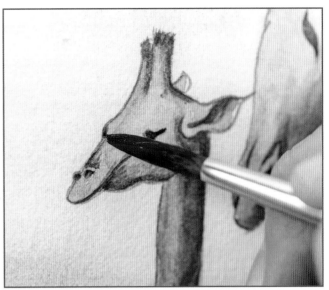

27 Add a grey shadow to the ossicones (horns) on the infant giraffe with a slightly jagged edge to the top. Use a clean, almost dry brush to gently blend those areas into the head. Add another dark shadow inside the ear, under the chin, going down towards the neck. Blend these with an almost-dry brush.

28 Add a tiny spot for the eye on the left side of the infant giraffe.

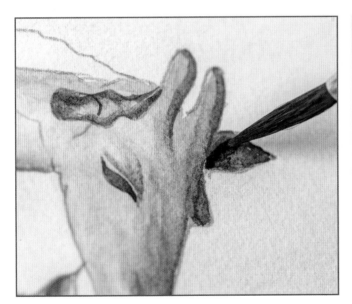

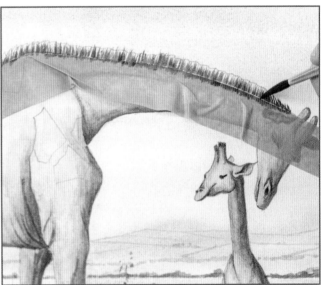

29 Paint a shadow over the top of the eye on the large giraffe. Blend this away with a damp brush, then add another shadow to the left ear with strong grey, working up against the the ossicone. Blend this inside the ear. Add an extra dark line inside the right ear. Allow to dry.

30 Add a strip of masking tape along the mane on the neck, being careful to follow the curve. Use a medium-strength orange-brown mix on a slightly dry brush, and quickly paint in little flicks, almost like grass, to add the mane. Keep adding more flicks again and again to add depth and fill the mane.

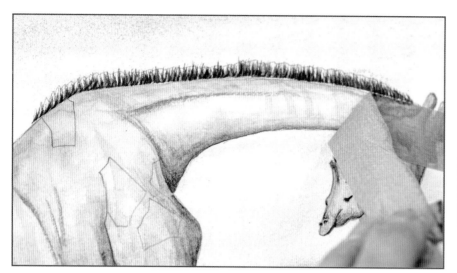

31 Add a touch of natural grey to the orange-brown mix to create a slight shadow colour. Still working with a dry brush, add some darkness, working upwards from the masking tape – this can be more spaced out. Gently peel off the tape.

32 Using a medium/pale strength orange-brown mix, paint in the spots which are slightly stronger in colour at the top and get lighter in tone as they drop down. Graduate the size of the shapes as you work down the body of the giraffe.

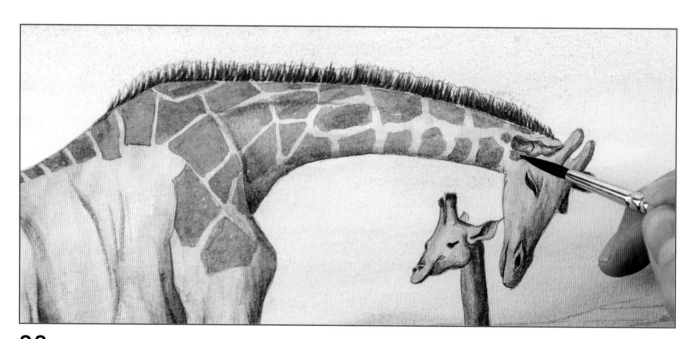

33 Work in a random fashion to fill the body of the giraffe with larger and smaller shapes, adjusting the size and shape to fit the contours of the giraffe. Note that the spaces between the shapes aren't always even – allow slightly more space around the shapes on the neck and as you work down towards the legs away from the body.

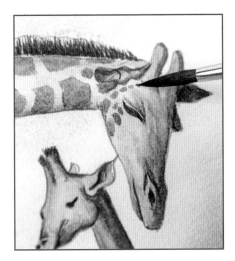

34 Add very small shapes on the face, following the contour of the cheek, across the top of the eye.

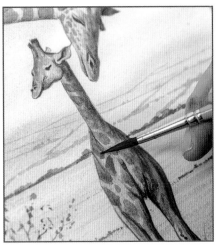

35 Add the spots to the infant giraffe in the same fashion, getting smaller as you work down the legs.

Tips

The colour of the spots should be light enough not to cover up the muscular contours that you added earlier in steps 15–18.

The spots, or patches, can be added randomly and in any pattern you wish.

On both giraffes, the patches almost turn into small dots as you work right down the legs toward the foliage. You can use paler paint to achieve this. Add more water to fade the markings down the legs.

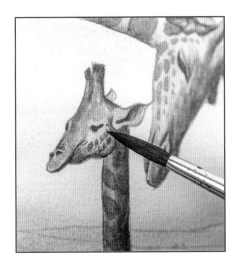

36 Using a slightly drier brush, add some colour to the head of the two giraffes, and more tiny spots to the infant's face.

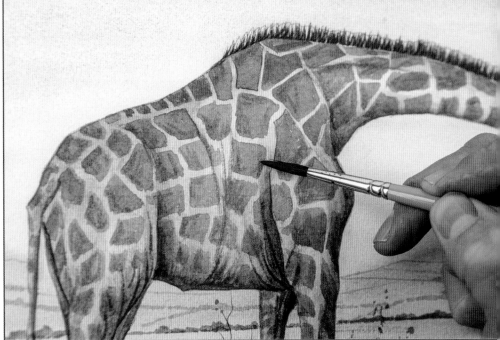

37 Once all the spots have been blocked in, use the same colour, with a slightly dry brush – removing the excess colour on tissue – to add dry-brush outlines to some of the patches. This will help them stand out and give a variation in colour tone – this is not needed on every spot, but add these as and when needed over the giraffe to add more depth, tone and texture.

Add highlights to the top of the tail where it connects to the body, and up the left side of the hind leg.

Add a highlight where the neck meets the mane.

Working across the top of the neck, add a highlight just above the dark shadow in the neck.

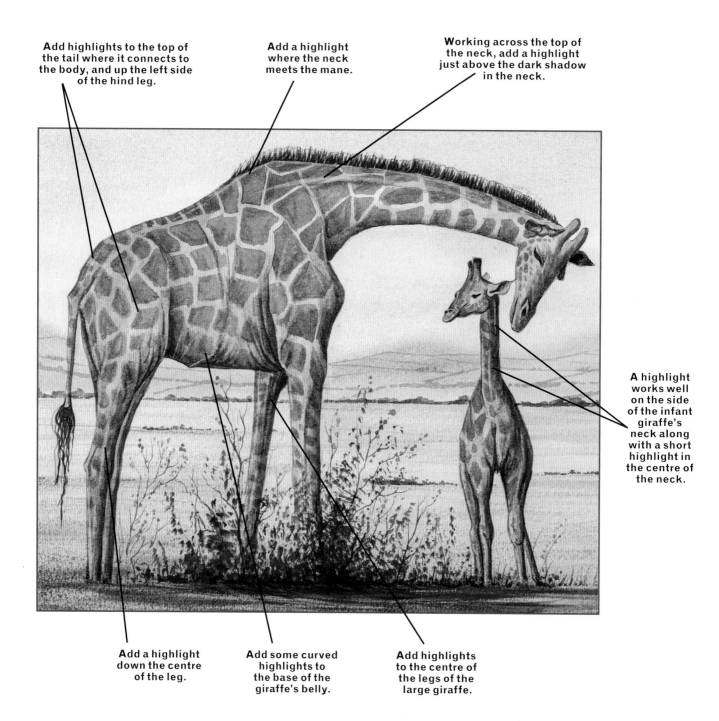

A highlight works well on the side of the infant giraffe's neck along with a short highlight in the centre of the neck.

Add a highlight down the centre of the leg.

Add some curved highlights to the base of the giraffe's belly.

Add highlights to the centre of the legs of the large giraffe.

38 Use a 6mm (¼in) or 12mm (½in) flat brush to add a few highlights to both giraffes, as shown. Where there are any dark creases or folds on either giraffe, adding a highlight next to them will increase the muscular definition and give a more three-dimensional effect.

39 Revisit your scene by adding some final details to the grass – use a size 6 brush with strong natural green and spot the brush onto the paper. Paint in some taller grass.

40 Use a medium mix of natural brown and natural grey and a size 1 brush to add more foliage around the giraffe's feet.

41 Using opaque white with a tiny bit of water on the tip of a size 6 brush, add a few white flowers around the dark area of foliage to give highlights to the base, by simply adding tiny spots with the tip of your brush.

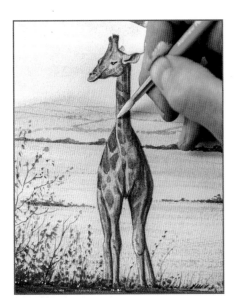

42 Finish off your painting by highlighting any areas where the dark shadows meet the light part of the giraffe. I've added the following highlights using white paint: a tiny white dot on each of the eyes; a line across the mouth of each giraffe; the base of the legs, working on the left side of each one; down the left side of the tail; a very fine highlight across the top of the mouth, separating the top from the bottom; across the top of each ear; across the top of the neck where it meets the mane; a few muscular highlights into the body following the contour, and a few white curved contours under the belly.

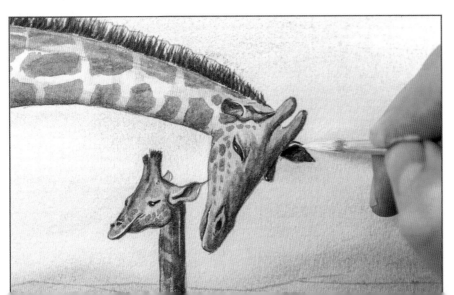

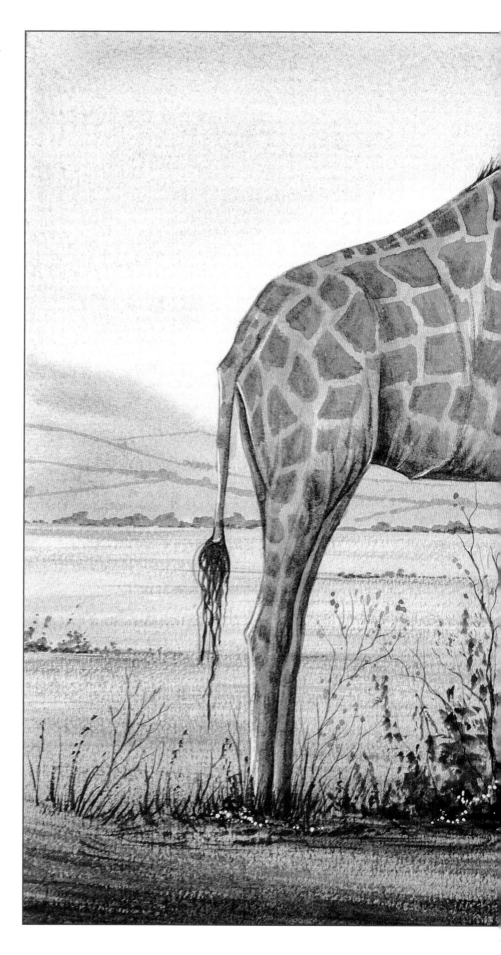

The finished painting.

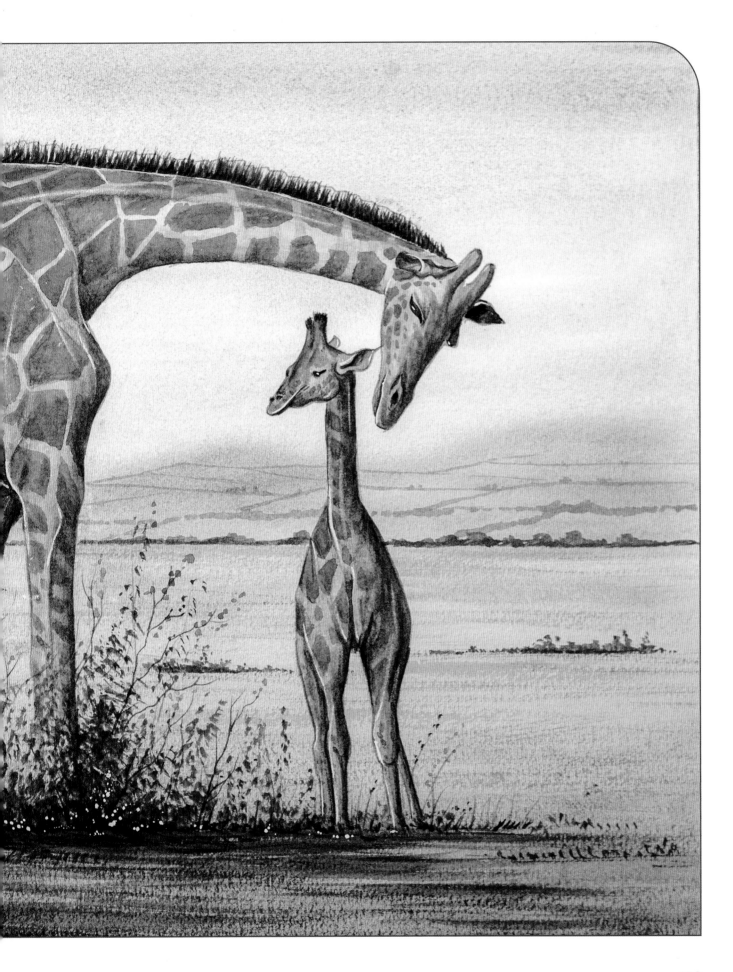

Index

A
adding water 18, 32
animal markings 14, 15, 20, 54, 87, 93, 98, 106–108, 112, 144, 155

B
background 14, 24, 60, 68, 82, 98–99, 116, 128–130
beak 51, 54, 57, 80
blending 28 and in every project
branch(es) 58, 77, 80, 147
brushes 11
 branch and detail 11, 38
 lift-out 11, 36, 79
 rigger 11, 44, 68, 82, 98, 116, 144, 147
 sable 11
 synthetic 11

C
cheetah 82–97
claws 11, 57, 58, 71, 79, 80
colour 14–21
 colour comparisons 19
 colour mix percentages 18, 20–21
 colour mixing 15
 colour wheel 16, 17
 primary colours 16
 secondary colours 17
 shadow mix 28
 tertiary colour 17
 using black 18
 white paint 8, 15, 38, 39, 80, 95–96, 112–113, 126, 140–142, 157
craft knife 12, 52, 66, 135

D
dolphins 60–67

E
ear(s) 29, 32, 38, 84, 88, 90, 94, 95, 117, 121, 126, 139, 141, 153
eraser 12
eye(s) 34, 38, 55, 64, 76, 92, 96, 110, 120, 123, 139, 141

F
feathers 57, 69, 72–73, 75, 77, 80
fur 14, 15, 18, 20, 44, 82, 90, 93, 94, 119, 121, 136, 141

G
giraffes 144–159
goldfinch 54–59
grass(es) 20, 23, 42, 157

H
hairdryer 12, 24, 25
highlights 6, 11, 15, 36, 37, 38, 39, 52, 66, 79, 80, 94, 96, 111, 112–113, 125, 126, 140

K
kitchen paper 12, and in every project

M
masking tape 12
materials 8
mixing palette 12, 48, 95

N
nose 23, 45, 46, 47, 84, 86, 88, 119, 139

O
ossicones 151, 153
outlines, using 48

P
paints 8–9, 14–15, 19, 38, 48
 traditional 9, 19
 National Collection 9, 19
panda 116–127
parrot 68–81
penguins 50–53
plastic food wrap 12, 98, 99, 101
polar bear 128–143

R
reactivating paint 32
reference photograph 93
ruler 12

S
salt 12, 128, 129
sandpaper 12
sea turtle 98–115
sketching 22–23, 48
sky 60–61, 128–129, 144
stripes 44, 45

T
tail 42, 51, 63, 102, 104, 113, 151
techniques 24
 adding facial features 44–47
 adding shadow 28, 29–33
 adding white paint 38, 39
 dry brush 34, 35
 feathering 45, 54, 55, 74, 76, 84, 85, 87
 finishing touches 40–43
 lifting out 36, 37
 using plastic food wrap 12, 98, 99, 101
 wet-in-wet 24, 25
 wet-into-dry 26, 27
texture 10, 12, 34, 42, 75, 88, 108, 113, 119, 121, 125, 134, 139, 141, 146, 155

W
water 60, 61, 62, 65, 66, 98, 99, 133, 134, 135
water pot 8, 12
watercolour board 12
watercolour paper 10
whiskers 46, 47, 95, 96
wing 52, 54, 56, 69, 71, 72